SECRET
IPSWICH

Susan Gardiner

AMBERLEY

*I am grateful to the following people for their help in researching this book:
Kingsley Fletcher, Liz Ixer, and the staff of Suffolk County Library and Record Office.*

First published 2015

Amberley Publishing
The Hill, Stroud, Gloucestershire, GL5 4EP
www.amberley-books.com

Copyright © Susan Gardiner, 2015

The right of Susan Gardiner to be identified as the
Author of this work has been asserted in accordance
with the Copyrights, Designs and Patents Act 1988.

ISBN 978 1 4456 4494 3 (print)
ISBN 978 1 4456 4514 8 (ebook)

British Library Cataloguing in Publication Data.
A catalogue record for this book is available from the
British Library.

Typesetting by Amberley Publishing.
Printed in Great Britain.

Contents

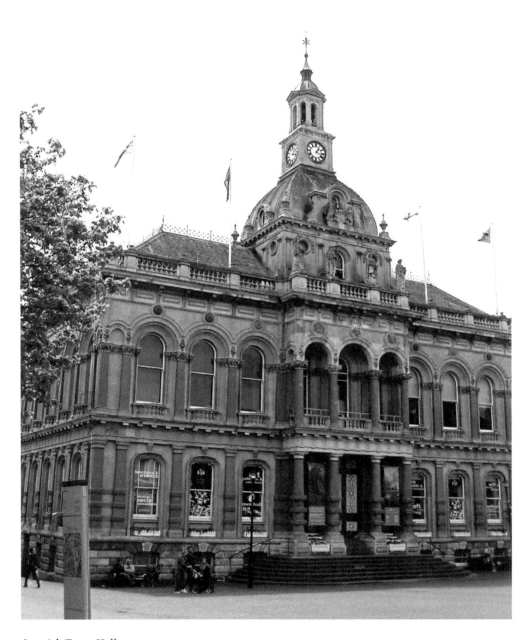

Ipswich Town Hall.

Introduction

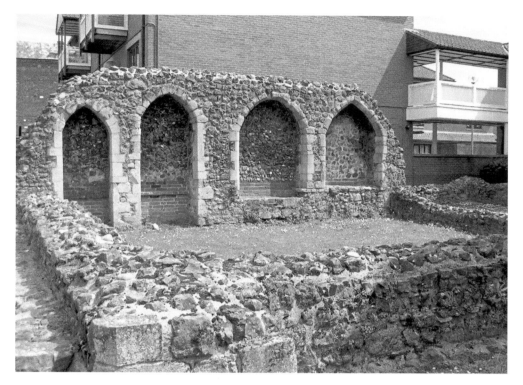

The ruins of Blackfriars.

In writing a book about secret, or hidden, Ipswich, a historian has a lot of material at her disposal. If the Suffolk county town cannot claim to be the oldest in England, it certainly has had the longest civic life, having been awarded a charter that recognised its status as a self-governing town by King John in exactly 1200. It has also, arguably, the oldest marketplace in the country, which continues to this day on the Cornhill. Hopefully, it will remain there, defying any local planners who might wish to 'improve' it by moving it to some inconvenient and sterile site away from the town centre.

Ipswich, like many towns of its size, has gone through periods of growth and prosperity, and also has had its share of poverty and deprivation. Currently, despite the efforts of politicians and business people to turn Ipswich town centre into yet another anodyne, identikit retail area, full of stultifyingly familiar shops, malls, fast food outlets and coffee shops, it still has a discernible, albeit rundown, identity of its own. The fact that the Great

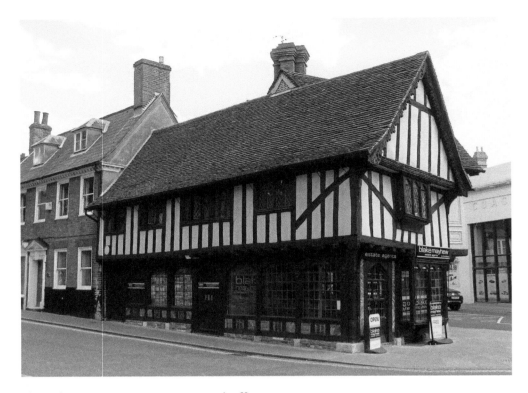

The Pack Horse Inn, now an estate agent's offices.

White Horse Hotel, made world-famous by Charles Dickens in *The Pickwick Papers*, is now host to an outlet of Starbucks seems symptomatic of the neglect of historic Ipswich sites by its people and those who represent them.

The natives of Ipswich have sometimes been quick to denigrate their town and little has changed it seems. In 1830, the writer William Cobbett visited Ipswich on one of his *Rural Rides*. The visitor was impressed by Ipswich with its many neat gardens, merchants' houses, and the well-cultivated surrounding countryside, but was told by everyone there that Bury St Edmunds was nicer: '... even at Ipswich, when I was praising that place, the very people of that town asked me if I did not think Bury St Edmunds the nicest town in the world,' However lovely and historic Bury St Edmunds is, and it is, it certainly does not hide its light under a bushel in the same way that Ipswich has always done.

Underneath what appear to be not-terrifically-mean-streets, is a place full of history and fascination: from the birthplace of Sir Thomas Wolsey to the burial place of Sir Alf Ramsey. It is a story of industry, Ipswich has been the pumping-engine and beating heart of the county of Suffolk for a long time. Indeed, so clever has Ipswich been over the centuries, that if that engine had not been a metaphor, it would certainly have been invented, built and run here. It is a story of constant change and innovation, with firms such as Ransome's exporting engineering products around the world and contributed greatly to the wealth of the nation. Its busy port has seen imports of everything from French wine to fine pottery

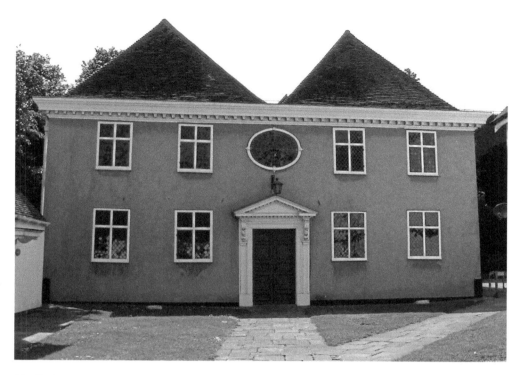

The Unitarian Meeting House.

and exports that included farm machinery to Egypt and confectionery products made by Burton's (whose warehouse was in the docks), such as Wagon Wheels and Jammie Dodgers to Russia. But it is also the story of political radicalism, enormous hardship, smuggling, brutality, murder and magic, a belief in which can be found in stories of witchcraft and cursings right up until at least the nineteenth century.

There have been many books about the history of Ipswich, and those who have an interest in the history of the town will not find many real secrets in here, although I hope they'll find a few. However, for anyone who walks around the town and glances above eye-level occasionally, or peeps into the small, ancient courtyards that hide behind what appear to be deceptively modern buildings, there is some genuinely obscure, hidden history, some of which, like the Ipswich Infidel Repository in Upper Orwell Street, need further research. Others, like the great palace that was on the junction of Silent Street and St Nicholas Street, or the shrine of Our Lady of Grace, are well documented by historians. Despite this, hundreds of people, if not thousands, walk past the places where they once stood every day without a second thought, not realising that, behind the pound shops and charity shops, are the sites of some of the most historic and interesting locations in England.

The story of Ipswich is also one of migration and change. Its current community is very mixed, with many languages being spoken and many different cultures living side by

A Cycling Touring Club sign, believed to date from the 1880s, on a shop front in Upper Brook Street.

side. This is nothing new. The town has been welcoming people from other countries and cultures since mediaeval times and probably earlier. Ipswich invited this influx of people with skills from Europe and elsewhere long before other parts of the country did and this indeed contributed to its wealth and status as a port, from Flemish weavers in the Tudor period, via the West Indian and Asian Commonwealth citizens who were persuaded to relocate here in the 1950s and 1960s, through to more recent European workers. These immigrants have contributed to almost everything that makes Ipswich such a vibrant and historic place, from its architecture to its industry. To the visitor, it has a genuinely continental feel. Perhaps the most famous building in the town, the fifteenth-century Ancient House on the Buttermarket, has the most beautiful pargetting which depicts the four known continents of the world. Ipswich has always been a place that has looked out into the world, rather than inward. Long may it remain so.

Ipswich contributed to the world with its outgoing migration too, being one of the first places to send people to settle in America during the sixteenth century, and continuing the process right through to the period after the Second World War when it 'exported' numerous Suffolk-born GI brides.

It has attracted painters, such as the Dutch artist Cor Visser (1903–1982) and has produced its own, Thomas Gainsborough (1727–1788), who lived in the town, and Maggi Hambling, a Suffolk-based artist who attended art school here. The artist Edward

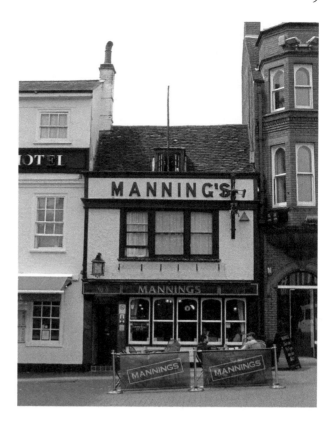

Manning's – one of the oldest pubs in Ipswich – opened as a wine and spirits shop in 1689.

Ardizzone went to Ipswich School in the Edwardian era, an experience so miserable that he never quite overcame it, but its picaresque aspects inspired some wonderful sketches of street-brawling women and neglected urchins. It has had a minor literary life (V. S. Pritchett, Jean Ingelow), and fascinating political shenanigans that took place in the eighteenth and nineteenth centuries.

Ipswich has been an important place in theatre history. It is quite likely that Shakespeare performed in the town, and absolutely certain that the actor David Garrick made his theatrical debut in Tacket Street. It has, and continues to be, a thriving place for the theatre, with the New Wolsey being one of several places that showcase local and national talent. Cultural festivals throughout the year add to the multiplicity of arts venues. It is a place of great sporting achievement too, having produced one of the greatest football teams of the twentieth century in Ipswich Town FC and England's two greatest football managers, Sir Alf Ramsey and Sir Bobby Robson, were an important part of that. All the following developed their sporting talents, at least in part, in Ipswich: the Olympic swimmer Karen Pickering, the late tennis star, Elena Baltacha, England international rugby union player Alexander Obolensky, and the England football captain, Terry Butcher. The town is now developing a reputation as a centre for competitive cycling.

Ipswich has long been a place of invention, innovation and adventure. Who does not want to know, for example, more about the reference made in the *Eastern Counties'*

Chronology (1906) to Benjamin Catt, who advertised his intention to fly in 1828? Poor Mr Catt was probably upstaged by the trial in Suffolk of William Corder that was going on at that time for the Red Barn Murder. We shall probably never know if he succeeded in his attempt to fly but Ipswich can boast of the world's first woman pilot, Edith Cook, who was born in Fore Street.

Ipswich even had, according to a glorious spoof website, a secret underground railway. In fact, Ipswich residents like other Suffolk people, have been obsessed by secrets, secret tunnels particularly, which are the subject of much speculation concerning mysteries that range from smuggling (undoubtedly part of Ipswich's more colourful past) to even more esoteric goings on.

Yet if you asked the average resident of Ipswich, they would describe it as a dull and uninteresting town, perhaps even a slightly seedy kind of place. In fact, they will probably tell you to go to Bury St Edmunds. It sometimes takes an outsider to see what someone too familiar with something can no longer see. I hope that the people who read my book will allow this outsider to show them some of the reasons why Ipswich should be regarded as one of the most historic and delightful towns in Britain.

<div style="text-align: right">Susan Gardiner, 2015</div>

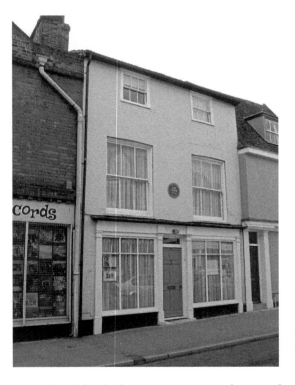

Above left: The house in Fore Street where Dutch painter Cor Visser lived between 1962 and 1982.

Above right: Portman Road, the ground of Ipswich Town Football Club, is owned by the Borough Council and has been important to the town since 1878.

1. Miracles on the Road to Mandulve's Well

Lady Lane is probably one of the most unprepossessing streets in Ipswich. In fact, it's more of an alleyway than a street. Yet in mediaeval times, this was one of the most important thoroughfares in the town. Nowadays people walk through this rather depressing, grey passageway en route to a car park, the Wolsey Theatre, or to football matches at Portman Road, but in the Middle Ages it was the place where thousands of pilgrims came, possibly from all over Europe. Neglected and litter-strewn, the alleyway is still sometimes a place of refuge for some of Ipswich's present-day homeless, who may be drawn to the statue of the Virgin Mary that is there, or perhaps simply seek its relative quiet and anonymity after dark. Between the thirteenth and sixteenth centuries, however, Lady Lane was a place of massive importance and international renown as the location of the Chapel of Our Lady of Grace, which was, along with Walsingham and Canterbury, one of the most prominent religious shrines in England.

Lady Lane in 2015 reveals little of its past as one of the holiest sites in England.

Before it became famous as the site of an important shrine, this thoroughfare was known as 'the road to Mandulve's well' and would have literally been just that: a track down to a water supply. But from 1219, mentions were made in various documents to an important church or chapel, called All Saints, almost always in connection with the nearby and locally important parish of St Matthew.

On both sides of the lane these days are modern shops although the streets beneath them, such as Westgate Street, are at least as old as the shrine. Nearby Tavern Street may well have taken its name from the fact that the thousands of pilgrims (and their servants) who came to Ipswich in the Middle Ages needed accommodation and this area was full of inns with names like the Assumption, the Cross and the Angel which may well reflect an association with the shrine. One of these inns was the Salutation (another name for the Annunciation of Christ's coming to the Virgin Mary) and a public house of the same name still exists in the town centre.

It's difficult to visualise what the chapel would have been like under what we can see in its place today, which is a modern brick structure, built in 1968 to house a Tesco supermarket. Facing what would have been the shrine's entrance, at the time of writing, is the 'Around a Pound' discount centre. There is little to suggest that this was a place of immense spiritual importance for hundreds of years apart from one, barely noticeable, statue of the Virgin Mary fixed to the back wall of a needlecrafts shop which now sits on what probably was part of the chapel and its cemetery. Beside this, from the early sixteenth century, were Daundy's almshouses – charitable single-storey dwellings for the poor – fifteen of them, built by an uncle of Ipswich-born Cardinal Wolsey, Edmund Daundy (sometimes known as Dandy). The almshouses were built on both sides of the lane to house elderly women and were a development built upon what had been St John's Hospital, which itself had evolved into almshouses. Daundy's almshouses were still there in the nineteenth century and were eventually demolished in 1877.

Lady Lane was just adjacent to the West Gate, (also known as the Barre Gate and sometimes called St Matthew's Gate), which straddled the road where what is now Westgate Street meets St Matthew's Street. The gate itself no longer exists but was a substantial enough building to have housed a gaol in the fourteenth century. Most towns had walls at this time and visitors had to enter urban areas through their gates. Ipswich was no different, although it did not have walls as such but was surrounded by ramparts – a circular ditch surrounded by a low bank which had been constructed by Danish occupiers to defend the town in the tenth century – and the West Gate was an important structure through which many people would enter and leave the town up until 1781, when a local court decided that 'Saint Matthew's Gate in this town be sold to the best bidder to be pulled down.'

The site of the chapel itself is well substantiated by archive records and it was built on an east-west alignment with the back facing towards St Matthew's church, a little in the distance. Behind the almshouses would have been nothing but farmland and marshes as far as the river Gipping. When the site was excavated by archaeologists in the early 1960s, before the present buildings were erected over the site, various pieces of church masonry (some window tracery, the base of a statue) were found which may or may not have come from the chapel and, at some time in the past, a pilgrim's token was also

found there, depicting the Madonna and child. Pilgrim's tokens were medallions collected on pilgrimages as mementos, or to show that someone had been to a particular shrine, rather like armbands from music festivals nowadays, and although it may have been an Ipswich token, it's equally likely to have been brought from Walsingham or elsewhere, and dropped by a visitor to the Ipswich shrine.

The chapel had a porch and stained glass windows, and the wooden statue of Our Lady of Grace, as the Ipswich Virgin Mary was known, was highly decorated and bedecked with jewels. The chapel has been dated (according to Stanley Smith in his book *The Madonna of Ipswich*) to around 1152, based on the work of archaeologist Martin Gillett. It was certainly well established by 8 January 1297. This was the date of the royal wedding of Princess Elizabeth, the daughter of King Edward I, to the Count of Holland, which was held at the chapel. The king came to Ipswich for the ceremony and held 'a splendid court,' and the records tell us that three minstrels were paid 50s each for their services. They must have been the medieval equivalent of Ed Sheeran to have been rewarded with such a handsome sum.

A collection of early documents known as The Woolnough Papers describes the shrine's significance: 'This chapel, and especially its celebrated image of the Virgin, made the name of Ipswich famous in ancient days on account of the miraculous powers in the curing of diseases which the venerated image was reputed to possess.' However, according to more recent research by historians John Blatchly and Diarmaid MacCulloch, this all pre-dates the cult of the Virgin Mary at this site by some time. In their book, *Miracles in Lady Lane* (2013), they claim that the association with the Virgin Mary dates from 1327, when a papal clerk in Avignon wrote to the Bishop of Norwich concerning the completion of the chapel in a place called Ypeçug [Ipswich] where a figure of Mary had been found underground. They use this to date the chapel of our Lady of Grace to around 1325–26. However this does not explain the status of the chapel of All Saints long before this date and its ability to attract visitors of very high status, including – as we have seen – royalty. It is also interesting that Ipswich had (and still has) several churches devoted to the Virgin Mary including St Mary Elms, St Mary-le-Tower and St Mary at Quay. Whatever the date of the foundation of Our Lady of Grace, a cynic might suggest that the discovery of the relic in Ipswich was fortunate, given the vast wealth that had been accrued by its neighbour in Norfolk, the shrine at Walsingham.

The Ipswich cult grew over time to become almost as famous as its northerly counterpart and the process was helped by the sudden appearance of 'The Maid of Ipswich' in 1515. Thomas More, Henry VIII's lord chancellor, described how he witnessed the young daughter of an Essex landowner, Sir Roger Wentworth, 'vexed and tormented by our ghostly enemy the devill, her mind alienated and raving with despysing and blasphemy.' The girl had insisted upon being taken to the shrine at Ipswich where she was brought before the statue of Our Lady of Grace where she was immediately and miraculously restored to health. The notoriety of the events that took place at the chapel attracted thousands of pilgrims in a few days and added greatly to the shrine's fame. This was the era when printed books began to be circulated in England, and by 1520, a local magnate, Lord Curson, had written *The Miracle of Our Lady of Ipswich*, and had it printed at Oxford. The period of excitement was relatively short for the Maid of Ipswich herself,

however, as soon afterwards her reward was to be sent to spend the rest of her life in a convent.

Many more important figures came to the shrine, including Henry VIII himself, but perhaps the most significant figure associated with the chapel is Thomas Wolsey who was born in the town and may have had family connections with the land on which the chapel had been built. At the height of his great power, the Cardinal began to build a college, which he planned to be as important as the one that he had founded at Oxford University. His fall from grace and subsequent death meant that the college was never finished and most of it was pulled down. Only a brick gate, on College Street, remains. The foundation stone of the college, also dedicated to the Virgin Mary, was laid on 15 June 1528 and it was intended that a procession from the college to the shrine would take place every year on the Birthday of the Blessed Virgin, on 8 September.

In fact, the procession probably only ever took place once, in 1528, going from

the West Door [of the College] through the whole length of St Peter's Street, then through St Nicholas' Street, past the house where the Cardinal was born, cross the Buttermarket, then by the Herb-market, then over the Corn-hill, past the Market-cross and the Town-hall, formerly St Mildred's Church, then through St Matthew's Street, under the West-gate and to the chapel of the famous image.

This is a route that anyone who knows Ipswich today would still recognize.

Following Henry VIII's falling out with the Catholic Church in Rome, and the rise of Protestantism in Europe, anything that was dedicated to the Virgin Mary became a target, as Thomas Cromwell oversaw the destruction of many monasteries and churches. As a shrine under the protection of the disgraced Wolsey, Ipswich must have been particularly vulnerable. In 1538, the statue was sent up to London to be destroyed. Bishop Latimer, who ordered that it, and other effigies taken from shrines around the country including Walsingham, should be burnt at Cromwell's house in Chelsea, suggested that they 'would make a jolly muster.' They would not, he added, 'take all day burnynge.' According to a writer of the time, John Stow: 'The images of our Lady of Walsingham and Ipswich were brought up to London, with all the jewels that hung about them...' all of which were burned by Thomas Cromwell. However, although the jewels that decorated it undoubtedly went to enrich the royal coffers, there were rumours for many years that the original image of the Virgin Mary had been saved from the bonfire and taken abroad.

An image of a similar description is kept in a church in Nettuno, Italy and is referred to in documents as having come from England. It is a depiction of the Madonna and child in a typically English style and is known as Nostra Signora delle Grazie (Our Lady of Grace). This is all circumstantial evidence, and there is no proof that the Ipswich statue still exists, but the modern statue in Lady Lane is based on the Nettuno image. A replica is also now in the church of St Mary Elms in Ipswich, not far from where the original shrine stood. In their 2013 publication, *Miracles in Lady Lane*, historians John Blatchly and Diarmaid MacCulloch demonstrate just how politically significant the destruction of the Ipswich shrine, with its strong association with Thomas Wolsey, was. They quote documents showing that Wolsey's successor, Thomas Cromwell used the image of Our

Lady of Grace as part of a propaganda campaign against Catholic 'idolatry' in 1538 and his accounts from early 1539 record the then considerable sum of £21 19s 7d received for 'stuff of Our Lady Chapel in Gypwich.' They argue quite convincingly that it would have been highly unlikely that the statue from Ipswich, so closely linked with Wolsey's power base, would have escaped the flames given its political significance.

The chapel of Our Lady of Grace was first merely closed, but it had been demolished by 1573. In 1650, there were stables on the site and by 1761, a Mr Grove of Richmond wrote: 'This Chapel is now entirely demolished, for there is not scarce one stone left upon another.'

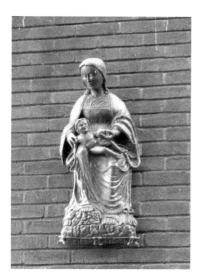 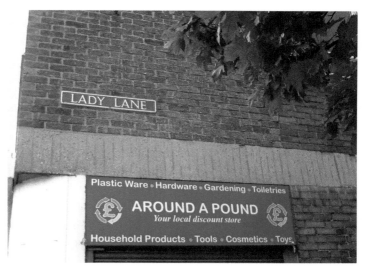

Above left: This modern replica in bronze by sculptor Robert Mellamphy, commissioned in 2002, is based on a statue in Nettuno, Italy.

Above right: This discount store on the corner of Lady Lane and Westgate Street was the site of the Three Feathers, a hostelry dating back to at least the seventeenth century.

DID YOU KNOW THAT...

The Around a Pound shop currently situated at the corner of Lady Lane and Westgate Street was for centuries the site of an inn called the Three Feathers, which closed in 1966. There was a pub of that name there from at least 1674, as it appears on Ogilby's map of Ipswich of that date. The Three Feathers was a symbol of Charles II and shows loyalty to his cause. Directly opposite was the Three Kings, another inn with a nominative connection to the Nativity story. Both stood just outside the West Gate and both may well have provided accommodation for pilgrims from the time of the shrine of Our Lady of Grace.

2. Lost Palaces

Like any other town centre thoroughfare, Westgate Street is full of familiar shops and chain stores these days. Two of them, Debenhams department store and Primark are busy and popular, perhaps for different reasons. Many local shoppers may not realise, however, that both are located on the sites of important Ipswich institutions of the past, albeit in newer, and less grand buildings.

The glass-fronted cube that is, at the time of writing, a Primark store replaced the public hall. Built in 1868 by the Public Hall Co., it was originally known as the New Music Hall, but by 1875 it was in financial difficulties and the liquidator, Mr William Turner, offered it to the borough council for £4,500. Originally lit by gas jets, the building's other claim to fame was to be the first building in Ipswich to have electric lights. Although it had various uses, for many years it was the place where the people of Ipswich were first entertained by that new American phenomenon, the motion picture. After 1892, it was hired out to a variety of companies that showed cinematograph films and audiences were able to see films projected onto a screen by the world's very first motion picture projector, the Phantoscope.

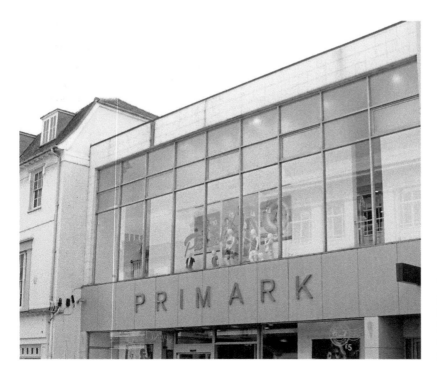

This Primark store stands on the site of the public hall, completely destroyed by fire in 1948.

In September 1900, the *Ipswich Journal* reported that a demonstration of Poole's *Myriorama* had taken place at the public hall: 'Whenever Mr Joseph Poole comes to Ipswich with his famous myriorama, the public can rely on seeing something new, and this is the secret of its popularity.' The myriorama was a moving panorama made up of still images. Joseph Poole and his brother ran seven touring shows around the country and enhanced the visual images of the myriorama with music, lighting, special effects (such as releasing puffs of smoke when guns were fired) and providing a narrator, usually one of the Poole brothers themselves in evening dress. Poole entertained townsfolk with a varied programme, typical of which would be images of British troops fighting in South Africa or the Sudan, but there would also be comedy, the Ipswich newspaper reporting that 'some of the pictures are also humorous enough to "make a cat laugh". However, successful the Poole brothers' panoramic displays were, they were doomed with the arrival of the cinematograph which prompted the opening of several picture houses in Ipswich.

From 1910 the public hall was licensed as a cinema proper, and after 1925, British Cinematograph Theatres, who also ran the more successful Picture House in nearby Tavern Street, showed films there. It was also the venue for other events such as civic concerts and was a popular place of entertainment but it was soon rivalled by commercial enterprises such as the Regent in St Helen's Street, which opened as a 'ciné-variety theatre' in 1929 and the public hall fell out of favour with the Ipswich public. The building was completely destroyed by a fire in 1948.

The Debenhams building, at Waterloo House, near Lloyds Avenue and the Cornhill, was the location of Ipswich's prime department store, Footman, Pretty & Co. from 1834 until it was demolished in the late 1970s. Before that, the junction of Westgate Street and the Cornhill was populated with narrower buildings, some of them very old, such as the Bell Inn (which closed in 1893 and became the site of Grimwade's clothing store) and the Corn Exchange Coffee House. On the other side of the street, was James Beart's General Drapery and Costume Warehouse, known as Waterloo House. In 1834, a corset manufacturer, William Pretty acquired the premises and joined up with local draper, John Footman and investor, Alexander Nicholson, to open what would become the most prestigious store in Ipswich.

There were many inns and public houses in Westgate Street, and one of the town's oldest inns was the Griffin, the main part of which is now W. H. Smith. The Griffin – not to be confused with the pub of the same name in the docks – eventually became a 'Family and Commercial Hotel,' the Crown and Anchor. It's still possible to see its ornate stonework on Smith's frontage today and the impressive doorway clearly belongs more to a hotel than to a newsagent. The Griffin, a much older building dating back to 1528, when it first appears in the town records, covered a wider area, was quite substantial in size and included a large yard behind the inn itself. In 1689 the Griffin appeared on the town assessment as one of only twenty-four inns in the town and it appears to have played a significant and important part of Ipswich history.

In 1728, a booth was erected for theatrical performances in the inn's yard. This did not meet with universal approval and when the booth collapsed in 1729, it prompted the publication of a pamphlet called *A Prelude to the Plays; or, a few serious Questions, proposed to the Gentlemen, Ladies, and others, that frequent the Playhouse; which they are*

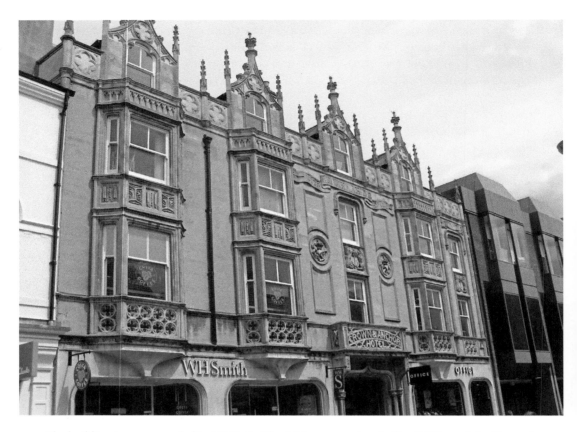

The building is now occupied by W. H. Smith which was previously The Griffin and the Crown & Anchor Hotel.

desired to answer deliberately to themselves, before they go again to those Diversions. The pamphlet's writer asked them: 'Could you never think that there was a rebuke of divine Providence upon those that attended these plays; when in Ipswich, and other places, their building fell down, to the hurt of many, and the fright of many more?' Despite the objections, theatre continued to flourish in Ipswich, as it does to this day.

In his history of Ipswich, G. R. Clarke refers to an inn called the Griffin mentioned in town records as paying 'only sixpence' in local tax in the mid-sixteenth century and the inn appears to have somehow survived the attentions of the zealous Ipswich Puritans of the seventeenth century. Leonard P. Thompson paints a picture of a flourishing inn and theatre a hundred years later in Old Inns of Suffolk:

Mr Lingwood records that Mr Dymer's Company of Comedians – 'Being desired by a Lady of Distinction' – presented, in November and December of 1735, The Provok'd Husband, and, later, The Miser, with The Mock-Doctor; or the Dum Lady Cur'd. This was announced as a 'Ballad Opera' with entertainments, 'and a Scaramouch Dance by a Gentleman of the Town for his own Diversion.' We cannot refrain from expressing

our curiosity as to who this obviously accomplished 'Gentleman of the Town' was, and whether, since he performed 'for his own Diversion', Mr Dymer paid him to do it, or if he paid Mr Dymer for the use of the stage! On December 8th, in the same year, Mr Dymer's Company performed 'The Beggar's Opera in a Burlesque Manner.'

Other entertainments than conventional theatrical performances were provided at the Griffin, however, as this advertisement in the *Ipswich Journal* of 29 November 1740 demonstrates:

There is Come to this Place and is now to be seen at the Griffin.
THE GREATEST CURIOSITY IN THE WORLD
The Miller that had his Arm and Shoulder Blade, with Muscles Back and Breast, torn off by a Windmill at the Isle of Dogs. He was brought to St Thomas's Hospital where he was cured by Mr Fern.
He has his arm and shoulder blade with him, where any Person may see him receive further satisfaction. He has the honour to be shown before most of the Royal Family and also the Royal Society.
N. B. – Upon giving Notice he will wait upon any Gentleman or Lady at their own Houses or elsewhere.

Westgate Street was also where, in much earlier times, Thomas Seckford, an Elizabethan politician and Member of Parliament for Ipswich from 1559 until his death in 1587, built his Great House, or as it was also known, Seckford Palace. He is more closely associated with Seckford Hall and his almshouses at Woodbridge, and he must have been immensely wealthy as he also had two properties in Clerkenwell, London. Judging by contemporary engravings of his Ipswich residence, it was certainly palatial with flagpoles, turrets, arcading and many large, ornate windows and it must have been extremely impressive in its day. It is from this house that the grand staircase now found in Arlington's Brasserie was taken, when the building was constructed in 1846 to house the town's museum.

This popular shopping street was once one of the busiest in Ipswich and Seckford's Palace or Great Place, which stood on the corner of Westgate Street and Museum Street, where the clothing chain stores Monsoon and Next now are, was one of the most magnificent buildings in the town – despite the fact that it was not Thomas Seckford's primary home in Suffolk. That was at Seckford Hall near Woodbridge.

At No. 44 Westgate Street during the 1890s were the premises of 'William Mills, ice and yeast importer ... Norwegian Lake Block Ice supplied all the year round' and, at the same address, no doubt dependent on regular supplies of ice in the days before refrigeration, were William Pooley's Native Oyster Rooms, established in 1839. His advertisements claimed: 'My native oysters are incomparable.'

Although Colchester, only fifteen miles from Ipswich, is better known for its oysters, Ipswich (and indeed other parts of coastal Suffolk) had a thriving oyster industry. They were farmed in the river Orwell, most notably near to Bourne Bridge but also further down river at Flagbury Point. Regarded as something of a luxury food now, oysters were for many centuries part of the staple diet of the poor and have been eaten in Britain since

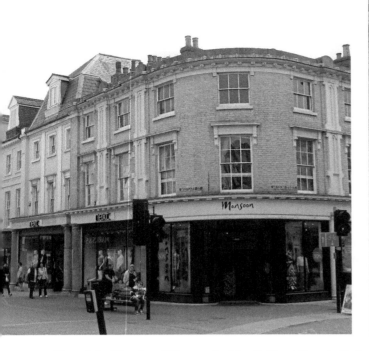

Above left: The site of Thomas Seckford's Great Place in Tudor times, now the premises of chain stores Monsoon and Next.

Above right: A single white brick high up on the old Odeon building in Lloyds Avenue commemorates the death of a worker during its construction.

at least Roman times – archaeologists regularly find discarded oyster shells at Roman sites, such as Combretovium, near Baylham. The Ostrich public house near Bourne Bridge was originally called Oyster Reach, because of the oyster farming that went on nearby, the modern name being a corruption of the latter. It has recently been returned to its original name to commemorate Ipswich's history in oyster production. It is not known whether William Pooley's incomparable oysters came from here.

DID YOU KNOW THAT...

Just to the north of Westgate Street is Lloyds Avenue where the Odeon Cinema was opened in 1936. On the side of the building next to the rear entrance to Debenhams, high up, it's just possible to see a single white brick, a touching memorial placed there in memory of a bricklayer who was killed when working on the cinema's construction.

3. 'A Street of Taverns'

Tavern Street is a continuation of Westgate Street, both of which would have been one of the main thoroughfares in and out of Ipswich in mediaeval times. Its name, of course, comes from the number of taverns and inns that were located there. Vast numbers of pilgrims were attracted to the shrine at nearby Lady Lane and they all had to be fed, watered and accommodated. This meant there was a great need for hostelries, not only for the pilgrims, but also for their servants and horses, all of whom would have been quartered in separate lodgings.

Despite attempts to regulate and even to close the taverns, inns and beer houses in the town, Ipswich always had a great many of them, and according to Julian Tennyson in his book *Suffolk Scene*, it was known as the Town of Taverns. Charles Dickens made the Great White Horse Hotel in Tavern Street internationally famous in *The Pickwick Papers* but all the other hostelries there have vanished. Revd C. Evelyn White, in *Old Inns and*

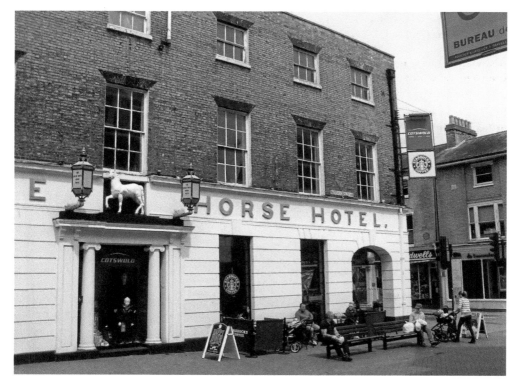

The Great White Horse Hotel made famous by Dickens is now a branch of Starbucks.

Taverns of Ipswich (1888), describes Tavern Street as 'virtually a street of taverns', and mentions the Royal Oak, which 'occupied part of the site upon which Mr Corder's drapery establishment now stands. It possessed a spacious courtyard.' He also describes the Mitre, 'one of the most important and extensive,' inns, which was at No. 30 Tavern Street on the corner with Dial Lane. Its name probably derives from it being built on the site of a religious building, the remains of which were discovered in 1846, when alterations were being made. It's not certain if it was the site of a chapel originally, but what is known is that the remains of two underground chambers were found beneath Tavern Street, and another in Dial Lane, the original building quite possibly extending as far as the Carmelite friary in the Buttermarket.

One of the earliest taverns in Ipswich stood on the corner of Tavern Street and Tower Street and is now where an impressive art deco style building (currently H&M) stands. Between 1250 and 1344, it was owned by the Malyn family, one of whom, Robert Malyn was a wine merchant (vintner), and of substantial means. He left his property, including the tavern and another in Dial Lane (then known as Cook's Row) to his son, John. According to historian Vincent Redstone, the district was called the Vintry and 'many of its taverns were owned or occupied by members of the Malyn family'. In a remarkable turn of events, a family dispute arose about the Malyn property after Robert's death, which involved the abduction of John Malyn, allegations of forced marriage and doubt being cast on whether

The site of the Mitre public house.

John was really Robert's son. Following several court cases in Ipswich, the property was distributed among several family members and John went to live in London where other family members already lived, using another of the Malyn's aliases (it was not unusual for people to use several different names at this time) of Le Chausseur – the shoemaker – the Malyns also had interests in leather goods and shoemaking. This later mutated to become the family name of Chaucer which was used by John's son, Geoffrey, the poet and author of *The Canterbury Tales*, who may or may not have visited Ipswich but can certainly be said to be a son and grandson of the town.

The Malyn's tavern on the corner of Tower Street later became the site of the Old Coffee House, a very popular establishment, which was certainly open in 1712, when town records record that Elizabeth Fosdick, presumably the proprietor, paid rent of £1 to the council. In the 1760s it became known as Dod's Coffee House, presumably after another of its owners, although the business seems to have changed hands rather frequently. Towards the end of the eighteenth century it had become one of the most fashionable places in town and was owned by a syndicate of ten people. It appears to have been a lucrative enterprise, several of its owners buying substantial property in Ipswich on the proceeds of its sale. The premises were extended into the building next door and became known as the Old Coffee House and Assembly Rooms. Central to the Ipswich social scene, it sold wines and spirits as well as coffee, had dining rooms, and was a venue for concerts,

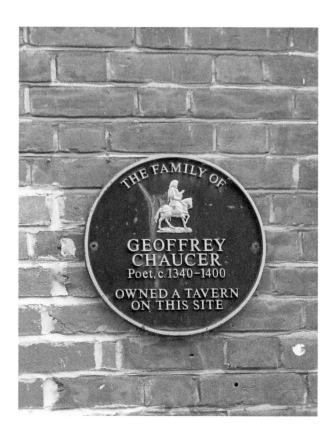

A plaque records where Chaucer's grandparents ran a wine shop at the corner of a Tavern Street and Tower Street.

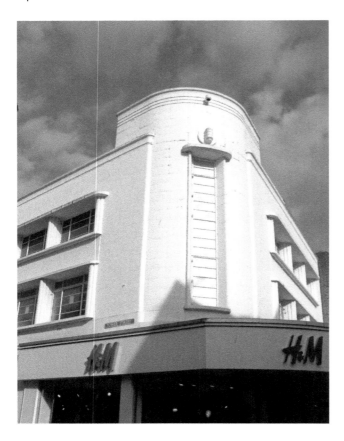

Once regarded as one of the most remarkable buildings in Ipswich, there remains no trace of Dod's Coffee House but its Art Deco replacement is also striking.

society balls, card games and, sometimes illegal, games of billiards. In 1798, the Coffee House was purchased by a local brewer, John Cobbold, who spent a great deal of money on improving the building.

The building that housed the Old Coffee House probably dated back to the middle of the sixteenth century, when Queen Elizabeth I was on the throne, and was often described as being the most impressive building in Ipswich. It was half-timbered with three gables but, most impressive of all, if contemporary illustrations are anything to go by, were the carved angle posts on the front of the building. Although they were described by the local historian, John Glyde, as being of 'undeniable grossness, and even vulgarity' – some of the figures depicted were naked – the carvings, representing a curious mixture of the classical, such as the three masculine and feminine graces and cruder versions of satyrs and other mythological creatures, appear to have been of the highest quality. The Old Coffee House lost its front section, including the remarkable carved posts, in 1815 when Tavern Street was widened. Tavern Street was nineteen yards wide and one of the busiest streets in Ipswich, used simultaneously by coaches, sedan chairs and pedestrians, and there were frequent accidents. The plan to widen the street was a popular one. John Cobbold was paid £30 in compensation for the loss of his façade, which was replaced by a white brick frontage further back from the street.

In 1864 the old Assembly Rooms building became Ipswich's Working Men's College, linked to the nearby Mechanics' Institute. There, it was possible for its members to take classes in book-keeping, arithmetic, chemistry and foreign languages, among other subjects. Photographs of the college's interior show neat lines of tables, where students were taught in rooms decorated with ornate plasterwork that was a reminder of glamorous times.

DID YOU KNOW THAT...

Geoffrey Chaucer's Ipswich family, the Malyns, were not only among the wealthiest in Ipswich through their wine and wool importing businesses, but they were also involved in a great deal of illegal activity including smuggling, abduction and even murder. In 1346, William Malyn was pardoned by the king for the murder of John Halteby, known as the 'King of Ipswich,' and several other family members were pardoned for 'all homicides, felonies, robberies, trespasses, and consequent outlawries' later the same year.

The corner of Tavern Street and Dial Lane.

4. Exotic Creatures and Protesting Women

Museum Street is a quiet street in the centre of town and no longer contains the institution that gave it its name. It was created at the same time as the museum was built – it was first known as New Street – and then included what would later become known as Arcade Street, a short stretch of road created around 1850 when an archway was cut through the premises of a failed bank, the Ipswich and Suffolk Banking Co. in Elm Street, which had been run by William Ingelow, the father of poet and children's writer, Jean Ingelow.

The museum building was designed by an Irish architect, Christopher Fleury and was situated at the corner of what is now on Museum Street and Arcade Street. It is, at the time of writing, a successful restaurant, Arlington's Brasserie.

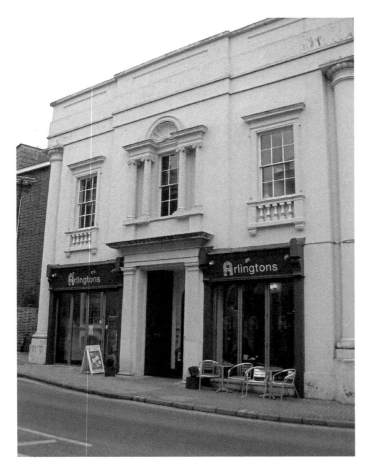

The restored Old Museum building, now a successful brasserie.

There had been plans to build a museum at Ipswich for some time before it was built. One of the prime movers behind the plans was George Ransome, a member of the Quaker family that owned the famous Ipswich engineering firm of Ransomes, Sims and Jefferies. The museum, unlike many similar institutions elsewhere, was designed to be for 'the benefit of the working classes' – a controversial idea at the time – and it was proposed from the beginning that free access to the museum and to any lectures held there would be made available to anyone who wished to take advantage of them.

On 15 October 1847, the *Essex Standard* made an announcement:

Ipswich Museum. We understand that the public opening of this institution will be celebrated by a public dinner, about the latter end of November, when every effort will be made by the spirited promoters to give éclat to a location so interesting to the inhabitants.

Other local newspapers frequently listed the donations and loans of items made to the museum, often made by former colonial or military officials who had picked them up from around the British Empire: 'By the Marquis of Conyngham, a beautiful specimen of the Gazelle, or Senegal Antelope, and a young crocodile; By Mr Wombwell, an Ocelot, a Tiger Cat, and a Nyl Ghau ... A splendid collection of Foreign Insects, chiefly from the Brazils ... By Geo. Ransome, a spear from the South Sea Islands...' and another list describes 'A gorgeous Chinese dress in scarlet satin, embroidered in gold: presented by Lieutenant W. T. Ethersey; ... Beautiful specimen of the Trumpet Shell, presented by W. T. Reynolds, of Halesworth; ... Fossil Turtle found at Harwich presented by the Revd F. B. Zincke...' There were many such lists and the museum acquired a huge stock of exhibits, which along with the huge success of its lecture programme, often attracted an audience of 400 or more people, made a move to a larger building necessary much sooner than had ever been anticipated.

One of the most important figures behind the early development of Ipswich Museum was Professor John Henslow, a brilliant botanist and mineralogist based at Cambridge University. Henslow was a mentor of Charles Darwin, with whom he continued to correspond and despite being a clergyman, was probably influential on Darwin's theories about evolution. Henslow had almost accepted a place on the HMS *Beagle* expedition but had decided not to go on what was an arduous two-year journey. In 1842, he had found some fossilised faeces, known as coprolite, near Trimley St Martin in Suffolk. This led to the invention of a process that enabled the high levels of phosphate contained in the coprolite to be extracted from fossils and used as fertiliser, which became part of an important industry in the Ipswich area and proved to be the beginnings of agri-chemical businesses that would eventually grow to become international corporations such as Fisons and Rhône-Poulenc.

The *Ipswich Journal* described the new museum enthusiastically in its edition of 11 December 1847:

The front elevation of the Museum is of a composite character; a kind of mixture of orders, and amenable to any rules of Grecian, Roman, or Palladian architecture. The

visitors will enter a vestibule, and ascend a spacious staircase, where there are niches and other spaces set apart for the reception of specimens. The Museum, which is entered by a pair of folding doors of plate-glass, is a noble apartment, being twenty-six feet in width and seventy feet in length. It is lighted from the roof via a lantern sky-light, so arranged as to admirably answer its purpose, an equal light being admitted to the whole of the apartment, so as to show off the specimens to the greatest possible advantage. Three pendent gas-burners of chaste design are placed at equi-distances. Around the room, the Committee has provided elegant mahogany glass-cases, whilst running parallel, the length of the apartment, and so disposed as to allow convenient spaces for the public to promenade, are two rows of mahogany glass-cases equally elegant in construction; the former for the reception of animals, the latter for entomological specimens. A Gallery has also been constructed along the principle of the Royal Adelaide Gallery at Charing-cross, with an iron railing, of tasteful design. The whole interior is very complete, and leaves nothing to be desired. A library is also attached to the institution on the ground floor... The various other specimens and curiosities have also been equally well arranged; and upon the opening of the institution there can be no doubt that the Ipswich Museum will be pronounced entitled to the hearty approval and support of the public.

Donations of curiosities continue to roll in to the museum, such as this example which was reported in the *Norfolk News* in December 1848: 'Mr Ward, innkeeper, Ipswich, has now in his possession a full-grown calf, with two perfect and distinct necks and heads, two tails, one body, and seven legs, one of which has two feet.' What the museum's curator did with this gift is not known.

The initial enthusiasm to provide access to the 'working-classes' was maintained, although between 1847 and 1853, admission was only available to people who could afford to pay for a subscription. Free entry was allowed in the evenings, however, when anyone could take advantage of the opportunity to listen to a member of the museum's committee 'explain objects' to them. Unfortunately, there were not enough subscribers to cover the museum's costs and in 1853, Ipswich Corporation took over its administration. William Barnard Clarke, a doctor, architect and archaeologist, as well as being a member of the Society for the Diffusion of Useful Knowledge, became curator. Clarke was not as well disposed to the open access philosophy of some of his predecessors and was horrified to discover that the public, or at least some of them, were 'dirty, smelly and noisy.' Clarke complained that 'a vile and disorderly mob ... contaminates our room on public nights.' They ran up and down the staircase, indulging in 'obscene conversations' that in turn led to 'indelicate and blasphemous retorts.' Despite the employment of attendants in the evenings, the situation was never fully resolved. Indeed, in 1871, for example, this item appeared in a newspaper report of Ipswich Petty Sessions: 'John Norman, a lad, pleaded guilty to damaging a book at the Ipswich Museum, by writing obscene language in it, and he was fined 2s 6d and 5s costs.'

Nevertheless, Ipswich Museum was a huge success and it was decided that it needed to be housed in a bigger and more suitable environment. A purpose-built museum was erected a little further to the north on High Street and it was opened in 1881. It is still the location of the town's museum today.

Following the move, the original building went through various incarnations, including periods when it was left empty. On 21 March 1874, the Ipswich Paving and Lighting Committee met to discuss the problem resulting from the fact that several properties in Museum Street had the same number, thus causing confusion and inconvenience to residents, Mr Fox and Mr Harrison, who attended the meeting to complain that they both lived at No. 5 Museum Street. This kind of thing was not, apparently, uncommon in Ipswich. According to the Vice-Chairman of the committee, there were five No. 5s in Bond Street alone. However, the committee decided that something must be done about the situation and renumbered some of the houses, and re-designated a short section of the road between the old museum building and King Street as being part of Arcade Street.

By the early twentieth century, the former museum was owned by an auctioneer who let parts of the building out for meetings. The neighbouring building, now an estate agents, Woodcock and Son, was rented by the Women's Suffrage campaign group, the Women's Freedom League (WFL). There were other, similar groups in Ipswich, such as the Women's Social and Political Union (WSPU), the organisation associated with the Pankhursts, but there were differences of opinion as to how the campaign for women to be allowed to vote was run. Some advocated militancy and even violence, others civil disobedience. The Ipswich branch of the WFL, run by a tireless campaigner called Constance Andrews, concentrated on tactics like refusing to pay taxes, in the form of,

The archway that gave its name to Arcade Street.

for example, fees for dog licences. This resulted in several women being sent to prison. Andrews herself was sentenced to seven days without hard labour for refusing to buy a licence for her dog, which she served in Ipswich Gaol. When the women were released, their supporters crowded the streets to acclaim them. A leading suffragist, and president of the WFL, Charlotte Despard, came up to Ipswich to greet the prisoners upon their release, and after a rally, described as an 'immense gathering' in the *East Anglian Daily Times*, the women and their supporters processed from Grimwade Street, via St Helen's Street, Carr Street and St Matthew's Street, to the WFL headquarters in Arcade Street.

There were strong feelings about the subject in Ipswich and it is notable that tickets for the 'Great Liberal Meeting' at the town's Public Hall on 11 January 1910, addressed by the Prime Minister Herbert Asquith, no less, included the clear instruction that 'This ticket will NOT admit a lady.'

The WFL moved to Arcade Street in March 1911, from Friars Street, soon after having been banned from selling their newspaper, *The Vote*, in the market place on the Cornhill. Only a few weeks after the move, Andrews led another campaign, which was part of a nationwide protest by suffragists to avoid appearing on the census. The reasoning was that if women were not regarded as full citizens with the same rights as men, then they would not fulfil their obligations as citizens to be recorded by the census. Suffrage campaigners were divided on whether it was a good tactic but the night of 2 April 1911 saw Andrews hiring a room in the former museum (now the Henslow Room in Arlington's Brasserie), for the purpose of avoiding the census enumerator. Although the presence of sixteen women and five men at 'the Museum Room,' was recorded, no details, such as names or ages were given, and 'NK' for not known was written in the record of every person who was there. The census enumerator wrote 'Suffragists' at the top of the list and, at the bottom, that 'more information given in Police Report.'

The protestors decided to hold an all-night party in the Museum Room at which they played cards and sang songs. Local newspapers reported that there were about thirty women present, more than the number who refused to give their details to the census enumerator, but this probably means that different suffrage campaigners came and went throughout the night.

In 1927, the building at No. 16 Museum Street had become the offices of an insurance company, and at other times it was the premises of an electrical contractor, a confectioner's, a dance hall and a bowling club. By 1948, it had become Arlington's Ballroom, a venue popular with locally based American servicemen and eventually the home of the Ipswich School of Dancing, run for many years by Olga Wilmot. It was presumably at this time that tales were told of the building being haunted by the apparition of a boa constrictor – presumably a former specimen from the museum days.

The School of Dancing moved to Bond Street in 1991 and the building became derelict until it was restored by its present owners. It is not known whether there have been any recent sightings of the ghostly boa constrictor.

The Museum Room where the 1911 Census protest was held.

DID YOU KNOW THAT...

Arlington's Brasserie, which is in the building originally designed to house the old Ipswich Museum, has a most impressive staircase, which was supposedly rescued from Thomas Seckford's Great Place (built around 1560) by architect, Christopher Fleury. Great Place stood at the top of Museum Street at the corner of Westgate Street.

5. 'Certen Straunge Players'

The Cornhill has been the trading centre of Ipswich since before it became a town and a market has been held there since Anglo-Saxon times. It was also where Ipswich local government was based for centuries. The town hall still stands on the south side, although the county and borough council offices have long since moved away. There was once a Market Cross there, which had a statue of Justice or the Roman goddess Flora on its roof. This statue was moved to the old Corn Exchange but was lost when it was rebuilt. It was last seen, in a dilapidated state, under a tree in Christchurch Park.

The Cornhill was also the site of the local Shambles, where the town's slaughterhouses were. Animals were killed and butchered, and the prepared fresh meat was sold there. From the fifteenth century until 1676, the barbaric practice of bull-baiting took place on the Cornhill and elsewhere in Ipswich. It was a local law, for example, that bulls had to be baited by dogs for at least an hour before they were killed and butchers who failed to do so were prosecuted. These were not the least of the cruelties meted out in this town square, now better known for happier events like celebrations of sporting triumphs and Ipswich's Christmas festivities.

The Cornhill was also the place where justice was administered, not only by courts held in the town hall but also where officially sanctioned retribution was put into practice:

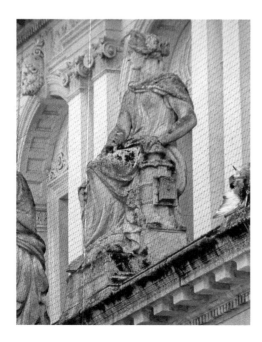

Electricity.

Above: On what was known as Bell Corner, this was for many centuries the site of the Bell Inn, later becoming the American Stores and then Grimwades.

Right: Commerce.

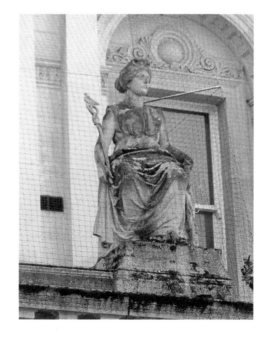

a number of Protestant religious martyrs were put to death here by burning, a most cruel and brutal punishment. A Catholic priest was hanged, drawn and quartered on the Cornhill and some unfortunate people died for their faith by being pressed or crushed to death by stones. This was not the place where general executions for criminal offences took place however. These were usually carried outside the town boundary at Rushmere. There were other forms of violent punishment that featured regularly on the Cornhill, for example, the self-explanatory 'whipping at the cart's tail,' the stocks and the pillory.

The pillory was used to punish a variety of miscreants, including those convicted of fraud or traders who gave their customers short measures, but a little known aspect of this particular form of 'justice' was that it was commonly used to punish homosexuals. In Ipswich, which appears to have taken a severe approach to those convicted of what was then a crime, offenders were often executed, but the pillory was also used as a punishment, as the following example from the *Ipswich Journal*, illustrates:

Ipswich, April 28 1739: At the Sessions held for this Town, on Tuesday and Wednesday last, three persons were indicted for Sodomitical Practices. The Grand Jury found the Bills against all of them; but only one of them, viz. Samuel Sherman appear'd; who, being tried and found Guilty, was ordered to stand in the Pillory, and to be committed to the Bridewell for three months.

An ornate window on the Cornhill where architectural styles span several centuries.

The pillory was not an easy alternative to prison or transportation. Although it has sometimes been depicted in popular culture as an almost light-hearted way of a community showing its disapproval of miscreants, where laughing locals threw rotten fruit at offenders clamped into its wooden frame, in fact, some people were killed in the pillory. As well as rotten food, all kinds of ordure including bodily excretions and dead animals were thrown, as well as bricks and stones. There is some evidence that homosexuals were often on the receiving end of the worst kind of treatment in the pillory.

In most serious cases, justice was administered at the Ipswich Assizes but some local courts sat in the town hall on the Cornhill, including the Pie Powder Court – named after the French for 'dusty footed,' pieds poudreux, which mainly decided on trade disputes, like short measures. The name derived from the swiftness with which justice had to be administered in the days when a dusty-footed itinerant market trader might disappear from the town within hours, in order to evade detection.

The town hall had been built on the site of the Moot Hall, where courts were also held, which in turn had replaced the tiny St Mildred's church, another relic of the Anglo-Saxon period of Ipswich history, which was incorporated into the new building. The Moot Hall had many functions apart from the administration of justice. It was where the Corpus Christi Guild – which has been described as a local trade union – met. It may also have been where the earliest theatrical performances in Ipswich were held.

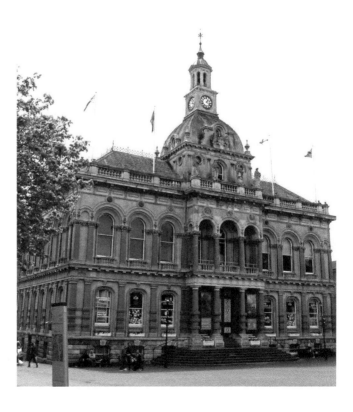

Ipswich Town Hall.

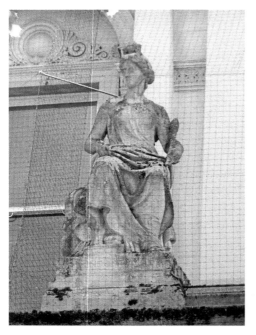 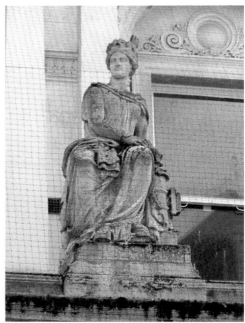

Above left: Industry.

Above right: Steam.

Sources vary considerably as to the date that plays were first performed at the Moot Hall. It may even have been the place where mediaeval miracle and mystery plays were performed. It was certainly where some of the earliest theatrical performances were made in the town and there is the tantalising possibility that William Shakespeare himself may have been one of the actors who entertained the people of Ipswich there. He certainly performed in the town, according to Peter Ackroyd in his biography of the playwright:

> Shakespeare came to know Ipswich and Coventry, Norwich and Gloucester, in the course of approximately twenty years of intermittent travelling "on the road." The company with which he was associated for most of his career, the Lord Chamberlain's men, travelled extensively in East Anglia.

This was at a period in Shakespeare's life when he was connected with a company of players called the Earl of Pembroke's Men, who certainly toured East Anglia. In the sixteenth century, it was often necessary for theatrical troupes to go on tour when the authorities closed the London theatres for reasons of disease or censorship. The Ipswich town accounts for this period record many payments to 'certen straunge players', including the Queen's Men, the Lord Admiral's Players and the Lord Chamberlain's Men, all of whom were associated, at one time or another, with Shakespeare. The borough would pay theatre companies as much as twenty shillings for their work. Sadly, the Ipswich accounts

are not extant for the period when Shakespeare was known to be touring with the Earl of Pembroke's players – who certainly visited Ipswich more than once – so unless more definite information comes to light, it will never be possible to prove Shakespeare acted in the town, but it seems very likely that he did perform in Ipswich and perhaps his plays were also put on there.

DID YOU KNOW THAT...

The old post office building on the Cornhill is a monument to Victorian civic architecture and the sculptures on it are familiar to most Ipswich people. What is less well known is that they all were given names when they were designed by W. F. Woodington, RA in 1880–81: Industry, Steam, Electricity and Commerce, all concepts beloved of the nineteenth century entrepreneur. Each female figure has a symbol that signifies which she represents, although Electricity's is missing. Steam sits with a small boiler, Commerce has a wreath and a *caduceus* (a staff) representing the Roman god of business, Mercury, and Industry is sitting on a beehive. Even less well known is that there are two words carved on either side of the Royal coat of arms at the top of the building, almost invisible to the naked eye: GENIUS and SCIENCE.

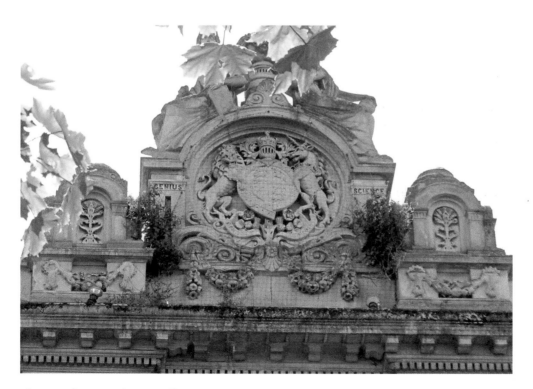

The coat of arms on the post office. Sharp eyes can spot the words Genius and Science on either side.

6. Merchant Princes and the Queen of the Air

Until the eighteenth century, Fore Street was called St Clement's Street and it was certainly the main thoroughfare that connected the centre of Ipswich with the parish of St Clement's, which was perhaps the poorest area of the town as well as being the location of the port and the river. It has been described as the most interesting street in Ipswich, and although it has many exceptional old buildings, the interest is not just architectural – it has many other stories to tell.

The architecture of the old merchants' houses in Fore Street is significant, however, and the most famous, and remarkable of them is Neptune House, formerly the Neptune Inn. The date, 1693, painted on the front of the building probably refers to a restoration or extension, as the back of the building is thought to be at least one hundred years older than the front. It was a tavern for at least two centuries until 1927 and was the place where labourers on the quay would collect – and no doubt spend – their wages. Having reverted to use as a private home, Neptune House can now be rented out for holidays or parties,

The Neptune.

having been lovingly restored. The mystery still remains, however, as to who was wealthy and important enough to have built Neptune House back in the sixteenth century.

All the merchants' houses, like the Neptune and Isaac Lord's premises a few doors away, opened to the river at the back and had lofts or warehouses where goods were moved between them and the ships. No. 99 Fore Street, now demolished, would have been a similar building and belonged to Thomas Eldred, a cloth merchant, who is famous for having sailed around the world with Thomas Cavendish in 1586, for only the second time after Francis Drake's expedition.

At the other end of the social scale from rich merchant-princes were the poor of St Clement's. One of the most deprived areas of Ipswich, mortality rates were extremely high. As in many ports, the ships and the fleeting visitors that arrived in the town with them brought disease, criminality and prostitution. In the Victorian era, philanthropists attempted to alleviate the problems in the district, but they were often religious or campaigners for teetotalism and their efforts didn't always meet with a great deal of success. Influenced by the People's Palace in the East End of London, the Ipswich Social Settlement, was founded by Ford Goddard in 1896 and would be a unique institution in Ipswich.

Originally built near some squalid old dwellings on Fore Street, Clarke's Court and Ship's Court, the Social Settlement's primary aim was to promote social welfare, health and education. A new, purpose-built community centre replaced the old courts and was

Merchants' houses in Fore Street.

opened on 16 October 1896. Although there were religious elements to the work of the Social Settlement, such as Bible classes, and some formal which education went on there – the Workers Educational Association held classes there from 1915 – social and recreational activities were regarded as being among the most important functions of the Social Settlement and children's parties concerts and fêtes were all held there. In addition there were facilities for billiards, bowls, exercise classes and a bicycle club. Later, dramatic and cinema performances were put on. The building was home to the Empire Cinema at one time. Unusually, although card playing was banned, alcohol was not and organisations that campaigned against the consumption of alcohol were not welcomed. The Social Settlement building was demolished as part of an improvement scheme in the 1960s.

No. 90 Fore Street, now the Neptune Café, was the birthplace of Edith Maud Cook, a woman who is little known by Ipswich people today, although the Suffolk Aviation Heritage Group is campaigning for a statue to be erected in her memory. This extraordinary woman was the daughter of James and Mary Cook, who ran a bakery and confectioner's shop. Edith was born there in 1878. Although she apparently claimed in an interview that she had run away from home at the age of fourteen, she was in fact working as a domestic servant at No. 125 Bramford Lane, Ipswich when she was fifteen, still living with her, by this time widowed, mother. It's thought that Edith may have been inspired to embark upon a career as a balloonist when she witnessed, along with a large

Carved window frames in the Neptune.

number of other Ipswich people, an ascent in the hot air balloon Eclipse made by Captain Dale at the recreation ground in Portman Road (now the site of the football stadium) in 1888. It is difficult to establish the facts about Edith's life as she appears to have adopted several identities, one commentator saying that she changed her name more often than she changed her dresses.

Something happened between that time and the early 1900s however, as at some point this poorly educated servant girl from Ipswich joined the famous Spencer Brothers, aviation pioneers, who also toured the country giving exhibitions of ballooning and parachuting. Edith worked for them for many years and became nationally famous as 'the Queen of the Air.' She would hang from an ascending hot air balloon until it had achieved a suitable height of around 3,000 feet and then drop, pulling open a parachute and descending to the ground. Despite several near accidents and the deaths of other men and women performing similar feats, Edith Cook – who performed under many pseudonyms, including Spencer Kavanagh and Viola Spencer – carried on parachuting.

In 1909, she expanded her interests and took up a place at Louis Blériot's flying school at Pau in France. Within a month she had learned to fly a Blériot XI single-seater monoplane. Later she joined Claude Grahame-White's British Aviation School also at Pau and in early January 1910 the British press reported that Miss Kavanagh has 'already succeeded in leaving the ground and so becomes the first woman of British nationality to pilot an aeroplane.'

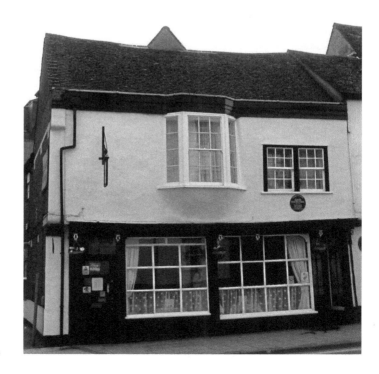

The Neptune café, birthplace of pioneer aviatrix Edith Maud Cook.

Cook was never to achieve her ambition of receiving her pilot's licence however, as on 11 July 1910, she had a serious accident when descending by parachute at Foleshill, Coventry. *The Times* reported that

> Miss Viola Spencer, in a parachute descent at Coventry on Saturday afternoon, alighted on a factory roof. The parachute turned over and Miss Spencer fell into the roadway. She was removed to the hospital seriously injured on the legs, arms and back. Miss Spencer has been making parachute descents for ten years.

She was taken to North Warwick Hospital where she died a few days later following an operation. The inquest identified Viola Spencer as Edith Maud Cook, originally from Ipswich. She was undoubtedly a remarkable and courageous woman and her importance in British aviation history is yet to be fully recognised.

Fore Street Baths were built by Ipswich Corporation in 1894 and provided a place where local people could have a bath, as well as a swim, in the days when most families did not have a bathroom in their home. There were other public baths, before Crown Pools were built, including those at the top of St Matthew's Street. St Matthew's Baths, now a gym, were the venue for boxing matches in the 1920s and 1930s and in the late 1960s and early 1970s, used as a concert hall, for which the pool was boarded over. Most famously, the rock band Led Zeppelin played at St Matthew's Baths in November 1971.

DID YOU KNOW THAT…

In the 1840s, Upper Orwell Street was the home of John Cook (1818–1901) and his family, who ran a newsagent's and bookshop called the Ipswich Infidel Repository. Cook was a campaigning atheist who sold literature promoting secularism and Chartism. Among his campaigns was a petition to Parliament to repeal the law so that Crystal Palace in London could open on Sundays. A short-lived journal of this time, The Oracle of Reason, or Philosophy Vindicated, which promoted atheism and was published between 1841 and 1843, listed Cook and his wife, Maria as subscribers to the Anti-Persecution Union: 'Mr J Cook, Ipswich Infidel Repository, Mr & Mrs Cook... 1s 6d.'

The Anti-Persecution Union was founded in 1842 to raise funds to defend the periodical's editors, George Holyoake and Charles Southwell, who had been prosecuted for blasphemy. Its aims were stated as 'to assert and maintain the right of free discussion, and to protect and defend the victims of intolerance and bigotry.' Cook was known to sell the Oracle's successor publication The Movement. According to Tony Copsey in his book about the history of booksellers in Suffolk: 'He took a prominent part in the political affairs of the borough [Ipswich] at the time of the Chartist agitation in the 1850s. He supported the formation of the Conservative Working Men's Association.'

Cook moved to St Helen's Street in the late 1840s, and continued as a newsagent for many years, but it is not clear whether his new shop was also known as the Ipswich Infidel Repository.

7. 'A Neat and Commodious Synagogue'

Rope Walk was originally known as Rope Lane and was marked as such on John Speed's 1610 map of Ipswich. It was the location of one of the town's biggest rope yards, although at that time it would have been surrounded by fields. Most towns of any size had rope walks, which were long narrow pathways, sometimes covered, and could be as long as 300 metres, so that the ropes could be laid out full length. The support industries of sail-making and rope-making were very important to Ipswich as a busy port but gradually, as the area was developed, the character of Rope Walk changed.

Located in the deprived area of St Clement's, by the 1820s Rope Walk was lined with terraced houses and tenements. Until the 1860s, it was also the site of a small pottery industry, and the Rope Walk Pottery, owned by the Schulen family who were descended from German immigrants, produced vases and plant pots, a thousand years after the town had been famous for its Ipswich Ware. Sadly, the pottery eventually ran into financial problems and at least one of the younger generation of the Schulen family ended his days in the workhouse.

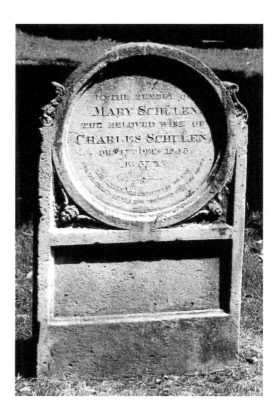

A memorial to the Schulen family, manufacturers of pottery.

Rope Walk was also the site of Ipswich's synagogue where its small Jewish community worshipped. According to the *Jewish Chronicle*, by 1840, there had been a congregation in Ipswich for over a century. At first, services took place in a hired room in St Clement's parish. A 'neat and commodious synagogue' was built in Rope Lane in 1795, which could accommodate up to a hundred worshippers, the foundation stone being laid on 18 August that year. Attitudes to this small Jewish community – estimated to be only fifty people by the 1830s – seem to have been variable. On the one hand, on 14 September 1793, the *Ipswich Journal* reported that there had been disturbances outside the synagogue. The tone of the report made it quite clear that both the local newspaper and the Ipswich authorities took a dim view of such behaviour:

> ...we are sorry to learn that [the synagogue] has of late been much molested by persons who assemble there, not out of curiosity, but to create a disturbance. On Saturday evening last they behaved in a very disorderly manner in the Synagogue, and used abusive language as the Jews retired. Constables have orders to be at hand, and examples will be made of such as offend in future; since in this country every man has the liberty of reverencing the Deity in that manner most consonant to his own conscience.

At around the same time, Ipswich's market day was moved from its traditional Saturday to Tuesday so that observant Jewish traders could continue to sell their goods there. It seems that, despite there being some hostility and aggression towards the small Jewish community in Ipswich, the general attitude of the population and the authorities was a positive one.

Ipswich was one of the few towns outside London where Jews had settled. By 1750 there was an established community. The plot for the Jewish burial ground within the parish of St Clement's was purchased by the community in 1796 and was in use for around 55 years. There is also a plot reserved for more recent Jewish burials in the town cemetery.

In about 1807, the Suffolk artist John Constable, famous for his landscape paintings, produced a rare portrait of a very old lady, who lived in the parish of St Peter's, Ipswich. The woman was called Sarah Lyon and she had been born in 1703, probably in Germany. Sarah Lyon died in 1808 at the age of 105. It is believed that she was buried in the Jewish cemetery, which was not far from Rope Walk. The few memorials that remain there today have mostly faded to illegibility and all are in Hebrew. One of them translates as 'the woman... 5565 or 5568 [1805 and 1808 in the Christian calendar].' This may well be the place where Sarah Lyon was buried.

The Jewish population slowly dispersed, mostly to bigger cities, and by the middle of the nineteenth century there were thought to be only five Jewish families left in Ipswich. By 1877 the synagogue had become so neglected that it was demolished and there were no Jews at all in Ipswich by the outbreak of the First World War. There has been something of a revival in the town's Jewish population, however, as the 2001 Census recorded that there were about four hundred people of that faith in the Ipswich district.

Ipswich gaol, although it was part of the huge County Hall complex that faced on to St Helen's Street, was so large that it reached almost as far as Rope Walk at the rear. Residents could hear the prisoners exercising or singing hymns. Built in 1796, Ipswich

The old Jewish cemetery.

prison seems to have had a harsh regime and, among other punishments, a Discipline Mill was installed. Also known as the treadmill, it was invented by an Ipswich-based engineer, William Cubitt, who worked for Ransome's, and had been tried out first in Brixton Prison. Although it was officially supposed to be a means of exercise and work for inmates, and not a punishment, its original name tells a different story.

The prison was the place where executions took place before the abolition of the death penalty in 1969. Seventeen-year-old William Aldous was publicly hanged outside the prison in April 1822 for setting fire to a barn at Stradbroke, possibly as a political protest. Aldous may or may not have been part of the movement in the early nineteenth century that was protesting against changes in the agricultural system that were leaving many labourers destitute. Whatever his motives, the boy was made an example of.

The last person to be publicly executed outside Ipswich gaol was sixty-three-year-old Edmund Ducker who had been convicted of the murder of a policeman. From then on, executions took place on a gallows built inside the prison. Hangings were relatively rare events, the last one taking place long before the abolition of the death penalty in Britain, when Fred Southgate was hanged for the murder of his wife in 1924.

Ipswich prison closed in 1930 and was demolished the following year. The site was redeveloped and is now an estate of public housing called Shaftesbury Square.

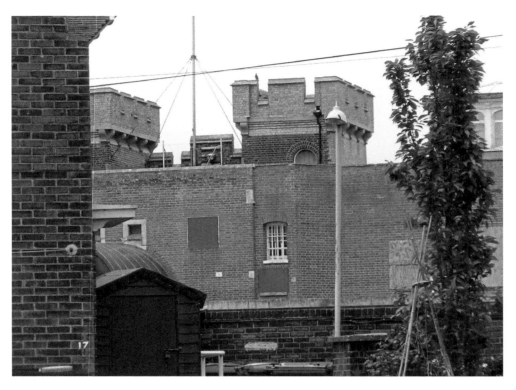

The back of Ipswich Gaol seen from Rope Walk.

DID YOU KNOW THAT...

Not far from the site of the Rope Walk synagogue is a tiny old cemetery, surrounded by a brick wall and only accessible through a padlocked wrought iron gate. This is where the Jewish community of Ipswich were buried before the new cemetery was built in the 1840s. It was in use between 1796 and 1865. Members of the synagogue purchased a 999-year lease from a local bricklayer, Benjamin Blaby for £28 and a peppercorn rent. By 1879 the burial ground had been so neglected that it was being used as a poultry run and a rubbish dump, but it was rescued and restored by the British Board of Jewish Deputies and the boundary walls are now listed as Grade II by English Heritage. The walls also contain two parish boundary markers, probably from the reign of George II, one marks the parish of St Clement's and the other of St Mary at Quay.

8. A Narrow and Leafy Track

The area around Christchurch Park in north Ipswich was semi-rural until the nineteenth century. Nearby Fonnereau Road was then known as Dairy Lane, and before that, in the seventeenth century, as Peddar's Lane. It was a narrow and leafy track – unofficially called Lover's Lane, because it was a favourite place for courting couples – until it became one of the first roads in Ipswich to be tarmacked, and huge Victorian houses were built along it. The pleasant environment there meant that the wealthy families of Ipswich chose this part of town to build their massive new homes. The name Fonnereau Road was taken from the wealthy immigrant family of Huguenots who came to this country in the seventeenth century to escape religious persecution. They owned substantial amounts of property in Ipswich and elsewhere, and had purchased nearby Christchurch Mansion in 1735.

Many well-known Ipswich families owned property in this area, such as the Packards, and Sherringtons, (in Anglesea Road), and the Quaker banking family, the Alexanders (in Fonnereau Road). The area also appears to have been something of an enclave for Ipswich's Quakers, including the Gurneys, Ransomes, Sims and Corder families as well as the Alexanders. Many were interconnected through both marriage and commercial interests. The Society of Friends (Quaker) Meeting House moved from College Street to No. 39 Fonnereau Road in the early twentieth century and many of these families went to meetings there.

Brightwen Binyon, another Quaker, moved to Ipswich with his mother in 1874 and lived at No. 43 Fonnereau Road. He became a very successful architect and among the buildings he designed were the Corn Exchange, the post office and the School of Art in Ipswich and the Felixstowe Pavilion.

Another resident of Fonnereau Road was Mildred Sims (1869–1915) who lived at No. 26. She was the first woman doctor in Ipswich, where she had a surgery in Queen Street from 1898 until 1911. She was the daughter of Elizabeth Gibb and Robert Ransome, of the famous engineering firm, Ransomes, Sims and Jefferies. Later, she married John Dillwyn Sims, another director of the firm. Sims studied medicine and surgery at Glasgow University, graduating in 1896, and also qualified as a midwife in Dublin. She took a particular interest in children who were living in institutions, and was also well known for refusing to accept payment from patients who could not afford treatment. Her career was almost certainly made possible by another Suffolk woman, Elizabeth Garrett Anderson, from Aldeburgh, who had become the first Englishwoman to qualify as a doctor in 1865.

Another noteworthy resident of this part of Ipswich was Nina Layard who lived in a house called Rookwood, at No. 8 Fonnereau Road. She came from a very wealthy upper class family. Her maternal uncles, Samuel and Joseph Somes, were both Members of Parliament, and had made their money in the unsavoury business of shipping convicts

26 Fonnereau Road, the home of Mary Sims, Ipswich's first woman doctor.

to Australia. Their niece – who was something of a polymath as well as a geologist, archaeologist, antiquarian, natural historian and writer – took a rather different path in life. Her partner from 1894 to 1935, Mary Outram, was also a talented painter and author. They had the private means which enabled them both to pursue their own interests. Layard worked tirelessly for the Ipswich Museum and the Public Library, both relatively new institutions and she made a significant contribution to Ipswich archaeology when she led the excavation of an Anglo-Saxon cemetery in Hadleigh Road in 1905–06, in a race against time as the Ipswich Paving and Lighting Committee had set a large team of unemployed men to work digging up the area in a road widening scheme. One hundred and fifty-nine graves and some important artefacts were found during the dig.

Anglesea Road, which is a continuation of Fonnereau Road in a north-westerly direction, was also known as Peddar's Lane until it was renamed after a marquis of Anglesey in the nineteenth century. Like Fonnereau Road, Anglesea Road was a more salubrious environment that was popular with the well-off families of Ipswich, one of which was the Sherrington family, which boasted Ipswich's only Nobel Prize winner, Charles Scott Sherrington (1857–1952), brought up at No. 107 Anglesea Road.

Charles and his brothers, George and William, lived there with their mother, Anne Sherrington and Caleb Rose, a surgeon, who was almost certainly the real father of all three boys. The man who the family claimed to be the boys' father, James Norton Sherrington, had died nine years before Charles was born. All three brothers were high achievers both academically and on the sports field. They were talented sportsmen, and

Rookwood, The home shared by Nina Layard and Mary Outram.

all of them played for Ipswich Town Football Club in its early days, having been involved in its foundation in 1878.

After qualifying as a doctor, Charles Scott Sherrington taught medicine at Oxford University and campaigned for the right of women to qualify as doctors. Among the many honours he was awarded during his lifetime were a knighthood, the Order of Merit in 1924 and the Nobel Prize for Medicine and Physiology in 1932. After a long and distinguished career, he retired to Ipswich where he served on the committee of Ipswich Museum, of which he was President from 1944 until his death in 1951 at the age of 94.

DID YOU KNOW THAT...

Anglesea Road, which is a continuation of Fonnereau Road in a north-westerly direction, was also known as Peddar's Lane until it was renamed after a Marquis of Anglesey in the nineteenth century. The 1st Marquis had commanded a regiment of light dragoons who were at one time lodged at the nearby barracks. A tunnel that runs parallel with Anglesea Road was discovered by workers repairing water mains in 1987, and it is thought that it may have been used as a cellar for the barracks. However, there may be other explanations for its existence and the tunnel's real purpose remains a mystery.

9. 'A Splendid Time is Guaranteed for All'

Cemetery Road sounds like a kind of metaphor for a stage on the path of life, but it is in fact, a long suburban street of neat Victorian houses, in an area that was once mainly populated by brickyards. It leads, as its name suggests, to Ipswich Cemetery, which was built in the middle of the nineteenth century and is still used for both burials and cremations today.

Cemetery Road seems a quiet backwater today, but it was the focal point of considerable danger itself when it was one of several streets in Ipswich that suffered severe damage in the Second World War. A mine was detonated there by a bomb disposal squad on 21 September 1940, causing a massive explosion, which destroyed one house completely and damaged one hundred and seventy-five more, twenty-five of them badly. The effects, including shattered windows, were felt in nearby streets as far away as the town centre.

Before the graveyard to which Cemetery Road leads was constructed, Ipswich once boasted the largest churchyard in Europe, which belonged to St Matthew's church. It was

A stonemason's works usefully located in Cemetery Road on a site cleared by a Second World War explosion.

certainly the largest graveyard in Suffolk after an acre of new land was added to it in 1801 in an effort to accommodate the increasing numbers of people dying in Ipswich. This was caused by a rapid influx of people coming into the town from the surrounding countryside in search of employment and the virtual absence of any sanitation. A report of the medical officer for health, investigating the 'excessive number of deaths' among infants at this time, described the river Gipping as being 'little better than an open sewer.' By 1850, local writers like John Glyde were highlighting what was becoming a public health crisis. All the churchyards in the town, except for St Matthew's, were full, or not fit for purpose. St Helen's churchyard, although very small, had been used for the mass graves of soldiers killed during the Napoleonic Wars in 1809: 'twenty or thirty were buried weekly and as many as sixteen in a pit,' according to Glyde, and he described the particularly unsuitable situation at St Lawrence's, which was (and is) right in the heart of the town:

> This is the smallest parochial burial ground in the town; and a worse situation for the purpose, it is scarcely possible to imagine. It is completely surrounded by very high houses, having no yards, and their back doors opening within three or four feet of the graves.

Ipswich also had a fast-growing population and a high death rate for a town of its size, having a mortality rate only slightly lower than the large industrial towns of the north of England, the infant mortality rate being especially high.

It was obvious that something had to be done about the problem and, in the typical Victorian fashion, a company – offering five hundred shares at £10 each – was registered for the purpose in 1849. Sand Pit Farm was brought from W. G. Fonnereau, a member of the wealthy Huguenot family that owned Christchurch Mansion, and a great deal of other property in Ipswich, during this period. Chapels were built in the cemetery grounds for Anglicans and Dissenters.

Ipswich Cemetery is now the location of some interesting graves, having been the main burial place for people who died in the town since it opened. One unusual headstone, which depicts a beautifully carved horse grazing between two trees, is the resting place of John Henderson, a well-known equestrian entertainer who died suddenly from pleurisy when his Henderson's Royal Circus was performing in Ipswich. The local newspaper, the *Ipswich Journal*, announced that 'This horsemanship, which is intended to make a stay in Ipswich of several weeks, is open every night and attracts large audiences. The horse riding is excellent, the gymnastic performances are of an unusually clever description, and the clown business is much above the average quality.' Henderson's death was reported towards the end of May 1867. The people of Ipswich rallied round and events were put on to raise money for Henderson's widow and E. F. Barber, the circus's manager, to whom credit is due for the respectable manner in which he has conducted the Circus since the death of the proprietor. 'New and startling novelties' will be introduced and a crowded house is anticipated. The show must go on, as the saying goes.

Ipswich is not, apparently, the most auspicious place for circus proprietors, or indeed other kinds of entertainer. Many years later, on 26 September 1966, the famous circus owner, Billy Smart (senior), died in the town while conducting the band at his circus zoo.

John Reginald Wombwell Bostock, also interred in Ipswich Cemetery, belonged to the family that owned the famous Wombwell's Travelling Menagerie, (also known as Wombwell's Royal Menagerie). He did not die in Ipswich but was resident there as the owner of the Hippodrome Theatre. The menagerie had been founded in about 1895 by George Wombwell, who made a collection of exotic creatures from all over the world. The Bostock family were show-people who worked for Wombwell and eventually married into the family. Bostock and Wombwell's menagerie toured the country exhibiting its lions, elephants, camels, zebras and snakes. The business eventually came into the hands of Edward Bostock, John's father. The menagerie continued mainly as a touring company and was very successful but eventually Bostock decided to open the Hippodrome Theatre in St Nicholas' Street in 1905 as the menagerie's English home – it had another base in Glasgow – and Edward presented the whole enterprise to his son, John, in 1919, after he had returned from fighting in the First World War. John had survived the war, unlike his brother, Alexander, who had died of wounds at Dovercourt, near Harwich in 1919, but his tenure at the Hippodrome was short. He was killed in a car accident near Cannock Chase in Staffordshire, in 1920. Both young men died in their early thirties and were buried in the same grave.

Another entertainer whose visit to Ipswich turned out to be unfortunate was Clifford Grey, real name Percival Davis, who died when he was visiting the town with the wartime troupe, the Entertainments National Service Association (ENSA) in 1941. Grey, who was asthmatic, died of a heart attack, thought to have been brought on by a heavy bombing raid in Ipswich two nights earlier. He had worked on Broadway and in Hollywood as a lyricist for George Gerschwin, Ivor Novello and Jerome Kern, and among his most famous songs were 'If you were the Only Girl in the World' and 'Spread a Little Happiness'.

Perhaps the most famous person commemorated in Ipswich Cemetery, however, is someone whose memorial is as unassuming and modest as he was in life: Sir Alf Ramsey, the great manager of the England national football team who won the World Cup in 1966, the only occasion that England have ever done so. Born in Dagenham, Essex in 1920 (then a rural backwater), he had been a very successful manager of Ipswich Town Football Club, winning the highest possible national trophy with them in the 1961/2 season, when they became champions of the Football League. Ramsey had settled in Ipswich, owning several properties in the town. His final years were spent living quietly in Valley Road. He died in an Ipswich nursing home on 28 April 1999.

The old cemetery, particularly, contains many interesting memorials that reflect the town's maritime history, including many graves of seamen and master mariners. The town's history is also reflected in the sections representing its different religious communities. In a quiet part of the old cemetery are a group of identical gravestones of a simple design, all with few details of the person who was buried there and without ornament. This is the Quaker section of the cemetery and follows Quaker principles of simplicity in everything. As well as Church of England and Non-Conformist areas, there are also Jewish and (since 1967) Muslim sections of the cemetery. Their memorials continue to tell the fascinating story of the people of Ipswich in all their diversity.

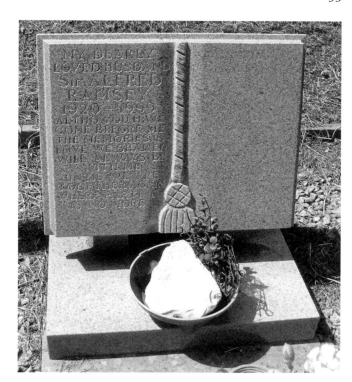

Right: This simple memorial marks where Sir Alf Ramsey's ashes were buried.

Below: The Quaker section of the Old Cemetery.

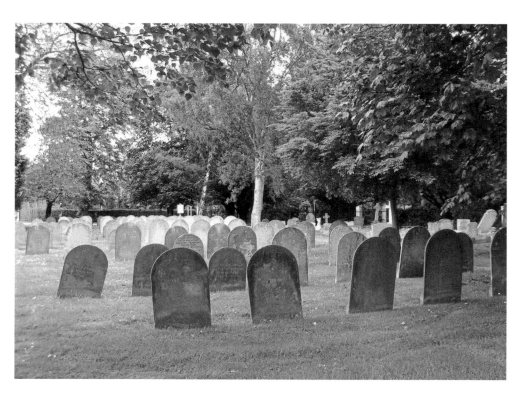

DID YOU KNOW THAT…

An interesting, and little-known, aspect to John Henderson's story is connected to a well-known Beatles' song. In the 1960s, John Lennon bought an antique poster for his music room which had advertised a performance by Pablo Fanque's Circus Royal on 14 February 1843 and stated that it was 'for the benefit of Mr Kite (late of Well's Circus) and Mr J. Henderson, the celebrated Somerset thrower! Wire dancer, Vaulter, Rider, &c,' which in turn inspired the lyrics of 'For the Benefit of Mr Kite' which appeared on the Beatles' 1967 album, *Sgt. Pepper's Lonely Hearts Club Band*.

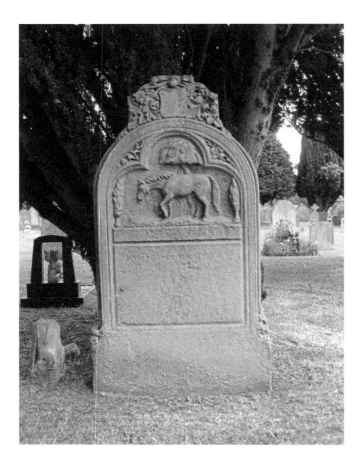

'For the benefit of Mr Kite':
John Henderson's grave.

10. 'A Dramatic Temple Worthy of the Town'

Carr Street has a most important place in the history of Ipswich but it is now an unremarkable street of unexceptional shops, remembered by older residents as the location of the old *East Anglian Daily Times* offices, and before that, as the place where the Lyceum Theatre once stood. Old photographs show the tramlines from when Ipswich public transport was provided by trolley buses.

Carr Street's significance goes back a lot further than this, however. Archaeologists have discovered that it was the place where the town's Anglo-Saxon pottery industry flourished. Ipswich Ware was sold and distributed around the country and possibly also exported. Other potteries in Britain at this time tended to make their goods for a local market and Ipswich was unusual – if not unique – in this regard. Although the remains of kilns have been found in the Buttermarket and also at Stoke, south of the river Orwell, the evidence from Carr Street clearly demonstrates that it was the centre of pottery production in the Middle Saxon period. Examples of Ipswich Ware have been found as far afield as Yorkshire and Kent but there is also clear evidence that Ipswich was a booming centre of international trade at this time and it may well have formed part of its trade with other European countries. Certainly, the wealthier Anglo-Saxon residents of Ipswich enjoyed drinking their imported German wine in fancy cups that had been made in Belgium or northern France, so it is not entirely fanciful to think that the town exchanged these for some of its own wares.

There appears to have been a pottery industry in the town from the seventh until the middle of the twelfth century, by which time the town's manufacturing and trade was dwindling, and it was instead becoming a place of Christian belief and worship. Ipswich was not only home to several orders of friars but the shrine of Our Lady of Grace (see chapter one) attracted pilgrims from far and wide. Many of the inns and taverns from that time had names that clearly alluded to the shrine and one of those was the Salutation. There is still a public house called the Salutation in Carr Street, and it is possible that there has been an inn or hostelry in Ipswich of the same name – but not necessarily on the same site – since mediaeval times. The name comes from the greeting or salutation given to the Virgin Mary by the Archangel Gabriel at the Annunciation. The building that houses the modern Salutation is nothing like as old, although it was an established place to drink by the early eighteenth century.

At that time, Carr Street was known as Cross Keys Street, after a hotel that was directly opposite the Salutation. Both names have religious connotations (Cross Keys being a reference to St Peter holding the keys to the gates of heaven) but both appear to have somehow survived the attentions of the Puritan troops who were billeted in the Cross Keys during the English Civil War (1642–51).

In the 1790s, the writer Clara Reeve, moved into a cottage in Carr Street. A successful novelist, she had been born in Ipswich in 1729, the daughter of the perpetual curate of

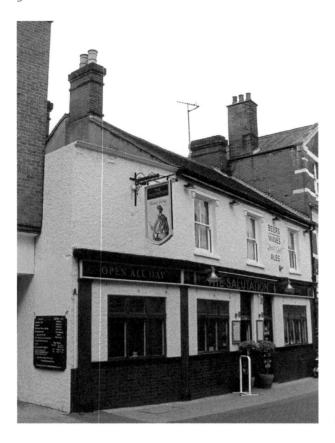

The Salutation, perhaps the oldest inn name in Ipswich.

St Nicholas' church. Her father had encouraged her to read and to educate herself, and, over a long writing career, she produced twenty-one books and a great many pamphlets. Her Gothic novel, *The Old English Baron*, is thought to have influenced several other writers including Mary Shelley, the author of *Frankenstein*. After living in Colchester for many years, she had returned to spend her last years in the town of her birth. Reeve was a reclusive woman who lived a very quiet life in Ipswich, where she died, and was buried in St Stephen's churchyard, in 1809.

In 1890, a famous actor-manager, Edward Terry laid the foundation stone of a new theatre, which was being built at No. 21 Carr Street. The architect was Walter Emden, who had designed many important theatres, including the Duke of York's and the Royal Court in London. In his speech, Terry paid tribute to another actor-manager, Mrs Keeley, who had been born as Mary Ann Goward, in Orwell Place, Ipswich, one of the many children of a tin man (a maker of tin goods) and brazier. When she was ninety years old, Keeley recalled that her father had supplied nails, hammers and sometimes props for the old Ipswich theatre in Tacket Street (which was in the Tankard Inn) and that she had been constantly in there 'all day and night, helping the carpenters and scene-shifters by fetching and carrying things for them.' Inspired by this early experience of theatrical life, she took singing lessons and was encouraged by local grande dame and patron of the arts,

Elizabeth Cobbold, to go on to the stage where she had an extremely successful career, often in 'breeches' (i.e. transvestite) roles. She married fellow actor, Robert Keeley and they jointly managed the Lyceum Theatre in London. When Edward Terry introduced her at the ceremony to lay the foundation stone of Ipswich's own Lyceum, he described her as,

> one of the greatest actresses of the day ... who at eighty-four years of age still retains her love for the stage, and has made a long journey to show the interest she takes in your proceedings; therefore, I repeat, in the face of this great dramatic tradition, it is only natural you should be anxious to go with the times, and possess a dramatic temple worthy of the town.

In 1911, the theatre was hired by campaigners for women to be given the vote, the Women's Social and Political Union (WSPU), to put on two plays, *The Apple* by Inez Bensusan and *An Englishwoman's Home* by Mr. Arncliffe-Sennett. The Lyceum began by showing dramatic plays but soon became a venue for variety acts, although as late as 1913, the performances that were put on there were quite a mixture, ranging from touring Russian dancers to cutting-edge drama such as Ibsen's *The Wild Duck* and Bernard Shaw's *Captain Brassbound's Conversion*. Just before the First World War, the Lyceum was taken over by the Bostock family who already owned the Hippodrome, and it was turned into a cinema. Between 1936 and 1952, the theatre was in use as a department store, the Universal Stores, and after that it became the offices of the Ministry of Pensions. Following the theatre's demolition, the Carr Street Shopping Precinct was built on the site.

A pertinent slogan on the Co-operative Stores's Central Drapery, opened in 1908.

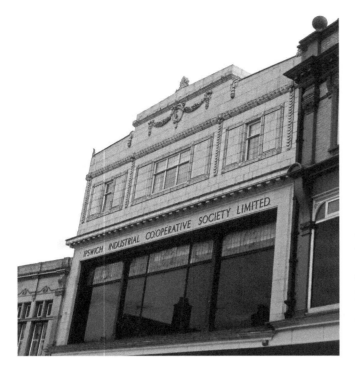

The main Co-operative building in Carr Street.

The Co-operative movement has always been strong in Ipswich. Its founding father, William King was born in this house in Lower Brook Street in 1786.

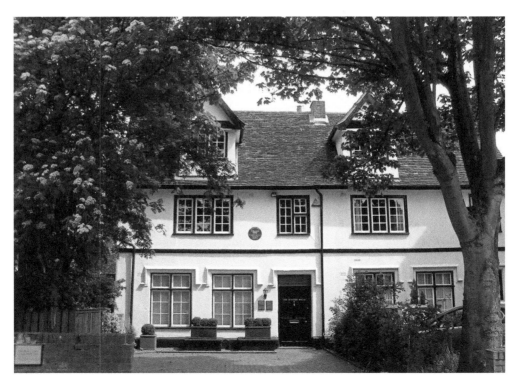

Ipswich has had a long association with the Co-operative movement, and there are many buildings in the town that reflect this. Carr Street was the site of a huge Co-op department store, built in several stages. Each phase of building reflects its time, from the decorative arts and crafts style of the 1908 central drapery at No. 48 Carr Street, to the Edwardian garlands on the grocery department built in 1915–16 and the art deco designs on the shoe department (1928). Underneath the building is a great deal of history too. When an extension was being constructed in 1961, archaeologists were brought in to investigate the large cellars underneath the Co-operative Stores. They found vital evidence of Ipswich's Anglo-Saxon pottery industry, including five kilns. Carr Street may look unremarkable to us today but there is a great deal to be discovered underneath its undistinguished surface.

DID YOU KNOW THAT...

A very fine and complete Tudor house was taken down in order to make way for the Co-op's Central Drapery to be built. For many years it has been generally believed that the house was shipped to the United States but recent research suggests that it may have been rebuilt at White City in London for the 1908 Anglo-French Exhibition and later added to an existing country house somewhere in England.

11. Gates and Walls

Northgate Street takes its name from the gate – also known as St Margaret's Gate – in the town's ramparts that stood at the top of the road, where P. J. McGinty's pub, is. Until quite recently, McGinty's was called the Halberd Inn. A halberd was a type of weapon, a combination of a spear or pikestaff and an axe – the kind of thing that is only used for ceremonial military displays by the yeoman of the guard at the Tower of London now. The original building is much older than it appears, and dates from the seventeenth century, although the exterior was rebuilt in the nineteenth. The Halberd Inn itself is aligned with the old tower ramparts and their remains can be seen in the walls of the south side of the building. More old stonework can be found inside the bar and the cellar of the pub, and are said to be what is left of the old St Margaret's Gate itself.

There are three other gates close by, all in the high walls that surround a very old building that is now the premises of the Suffolk Club. When Northgate Street was

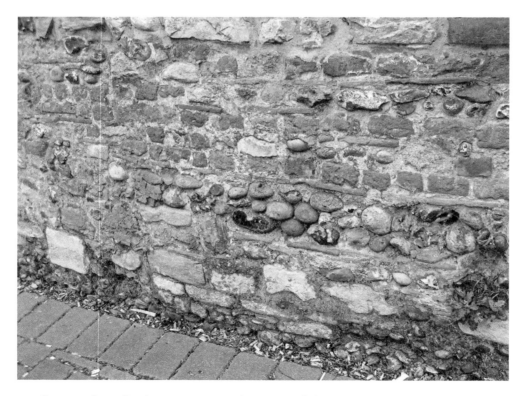

A wall near to the Halberd Inn using stones that were probably once part of the town ramparts.

still known as Brook Street (Brocstrete) this was the Archdeacon's House, convenient for when the incumbent was in town for the Archdeaconry Court, which was held at St Mary-le-Tower. This court decided on ecclesiastical matters and disputes about wills. Not all the archdeacons of Suffolk would have lived in the house – at least one was also a cardinal and a bishop with a diocese in Italy – but the grandest of the three gates – which was a gatehouse, in fact – is named after one who did, William Pykenham, who was archdeacon from 1472 to 1497. The high walls surrounding the house were there to protect the Archdeacons from the local population. Before Pykenham's time, during the 1381 rebellion known as the Peasant's Revolt, the house had been attacked, and there were other times of tension between the people of Ipswich and these wealthy representatives of ecclesiastical power. The Peasant's Revolt, however, coincided with the time of the usually absent Italian bishop, and it is thought he was probably not at home.

By the eighteenth century, the Archdeacon's House no longer housed Anglican clergy but instead provided the premises for a series of doctors and surgeons. During the nineteenth century, according to historian, John Blatchly, the building was owned by Barrington Chevallier (of the Aspall cider family) who used it as a private lunatic asylum.

At Nos 2–4 Northgate is a blue plaque that records the role of John Harbottle, an Ipswich businessman, in the Kett Rebellion of 1549. The uprising, which was much more serious in Norfolk, was a protest against the increasing enclosure of common land by rich landowners. This involved fencing off and essentially privatising land that had from time immemorial been open to everyone. People who had used common land to graze their livestock for

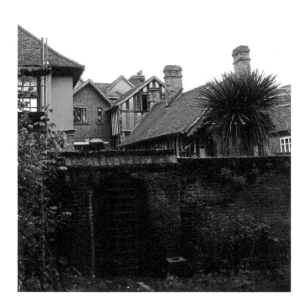

The backs of houses in Northgate Street. The archdeacon's house is on the left.

decades were effectively forced into poverty. This provoked public demonstrations, all over the country but particularly in the east of England. The Norfolk rebellion was serious and ended badly for the rebels. Over 3,000 were killed and more than three hundred, including its leaders, were hanged as an example to others. Things were rather different for Harbottle and the small number of Suffolk rebels. Although they don't appear to have achieved anything very much, they managed to negotiate a peaceful conclusion to their protest, and John Harbottle himself carried on as a respected Ipswich dignitary until his death in 1577.

Although they are hardly secret, Northgate Street is also home to some of the most impressive architectural features in Ipswich. The half-timbered Oak House at No. 7 Northgate Street, which at one time was an inn, has some interesting carved angle posts which depict, among other things, a blacksmith at work, dating from around 1530. Above the doorway is a carved wooden crest with a motto, *ne tentes, aut perfice*, which translates as 'do not attempt, but succeed'. Presumably these are the heraldic remains of a family that once lived in or owned Oak House.

The rather grand building at Nos 3-4 Northgate Street has had many diverse uses over the years, including as a girls' school, a Sketchley's dry cleaners and a toy shop, but it was built as the New Assembly Rooms in 1821 to replace the ones around the corner in Tavern Street (see chapter three). An elegant two-storey building then, the rather clumsy upper-storey was a later addition. G. R. Clarke described the New Assembly Rooms in his *History of Ipswich* (1830):

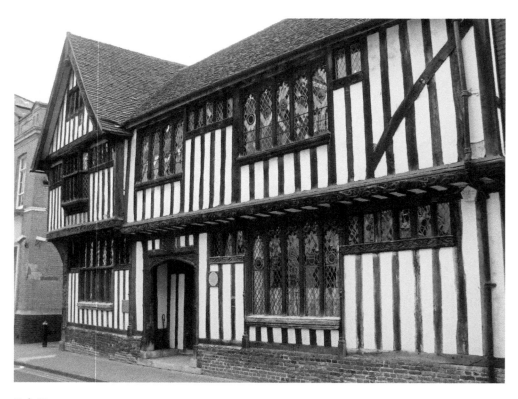

Oak House.

Adjoining the Great White Horse, in Northgate-street, is an elegant suite of apartments called the New Assembly Rooms; comprising a supper and ball-room, card-rooms, news-room, etc., with all the requisite offices. They were built under the direction of Mr George Mason. The front is handsome; and in the erecting and fitting up of the premises, much taste has been displayed. They were undertaken by subscription, of shares of £50 each, in the year 1809: but owing to some unfortunate misunderstanding among the subscribers, the funds were not sufficient to defray the expenses incurred. There are six monthly balls during the winter... and there are about a hundred subscribers.

In its time as the New Assembly Rooms, the building was hired by a wide range of local organisations including Ipswich School of Art in 1859 before its move to High Street and, in the 1840s, it was also the meeting place for some of Ipswich's Masonic lodges, including the British Union Lodge and the Lodge of Perfect Friendship.

In 1878, it became a girls' school, opening with only forty-three pupils, although Ipswich Girls High School eventually became too successful to be housed in such a small building and in 1905, it moved to Westerfield Road and is now at Woolverstone Hall about five miles from Ipswich.

It is not immediately obvious when looking at this building that it was also the place where Reginald Egerton had his first motor car works in the town. It is still possible to

The New Assembly Rooms have seen many changes since it opened and it now stands empty.

make out the faint words 'motor works' on the upper storey of the building at the front and 'Egertons' at the back. Egertons were an important firm in Ipswich and would later own a lot of property in this area, including a building adjoining the Halberd Inn and substantial showrooms along Crown Street.

For some years, the Chicago Rock Café was based here, and more recently, it has been a bar and nightclub, its most recent incarnation being Groove, which closed in 2013. For many, the building's use as a nightclub might seem inconsistent with its history and mock-Classical architectural style, but arguably by being used for such a purpose, Nos 3–4 Northgate Street was simply returning to what it was back in 1821: a place for dancing, socialising and the possibility of romance.

The back of the Assembly Rooms building showing the signs of its time as Egerton's Motor Works.

DID YOU KNOW THAT...

Among the alumnae of Ipswich Girls High School, although from later in its history than its Northgate Street years, were the children's writer, Enid Blyton who trained as a teacher there, and the actress June Brown who played the character Dot Cotton in the BBC soap opera, *Eastenders*.

12. 'The Dullest and Most Stupid Place on Earth'

Tower Street, which is narrow by modern standards, could legitimately claim to be the most significant place in the history of Ipswich. It was here, in the churchyard of St Mary-le-Tower, that King John's royal charter was read, in the year 1200, giving Ipswich the relative freedom of self-government. Fifteen years before the Magna Carta, Ipswich was able to elect its own officials: bailiffs, coroners and portmen. Portmen are now best remembered as having given their name to one of Ipswich's most famous streets, Portman Road – before development, portmen had the right to graze their animals on the marshes in that part of town – but they were very important figures in Ipswich from the royal charter onwards, having a similar function to aldermen in other parts of the country.

St Mary-le-Tower, impressive as it is with its sixty-metre spire, is a Victorian church although it retains some much earlier features such as its mediaeval carved bench ends and eighteenth-century pulpit. It is still known as Ipswich's 'civic church' today. Even before 1200, it was the place where folkmoots were held. These were an Anglo-Saxon form of local government, public meetings or hustings where bailiffs and other community representatives were elected. We know that there was a church of this name from at least the eleventh century because it was mentioned in the Little Domesday book of 1086 as Sancta Maria ad Turrim – St Mary at the Tower. Often interpreted as meaning that the old church had a high tower itself, it's more likely to have been a reference to the area, as other landmarks, including the Tower Ramparts, did and, of course to distinguish it from the other churches dedicated to the Virgin Mary in the town.

There are several memorials to the Cobbold family – who have been important in the town's economic and cultural life since the eighteenth century – in this church, including one to Elizabeth Cobbold. Born in London as Elizabeth Knipe in 1765, her second marriage to the brewer John Cobbold in 1791 brought her to live in Ipswich, first at the Cliff, where the Cobbold's brewery was and later at Holywells Park. It was from there that she produced many works of poetry, as well as taking up natural history, arts and crafts. She also became the patron of other aspiring writers, especially from what was then known as the labouring class, something that was particularly fashionable at the time. Among these was Ann Candler, a Yoxford-born woman who earned brief fame when she published her poetry while living in the workhouse (Tattingstone House of Industry). Ann, who had been abandoned with six children (three more died in infancy) by her husband, spent over twenty years in the workhouse, but after publication of her work in the *Ipswich Journal*, Elizabeth Cobbold edited and helped her publish a volume of poetry, *Poetical Attempts by Ann Candler, a Suffolk Cottager* in 1802 which enabled Candler to move out of the workhouse and into a home with one of her daughters.

Elizabeth Cobbold's own verse was essentially quite terrible but she had something of a reputation as a society hostess and poetaster, and it's likely that the character of

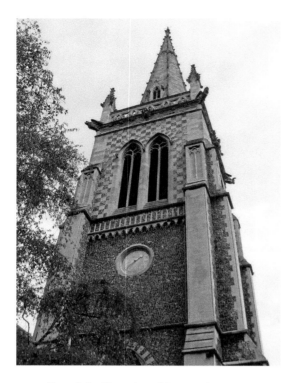

Above left: The spire of St Mary-le-Tower.

Above right: Tower House, or St Mary-le-Tower Church House.

Mrs Leo Hunter, in Charles Dickens' *Pickwick Papers* was a merciless parody. Set in the fictional Suffolk borough of Eatanswill, Mrs Leo Hunter supported her husband's political ambitions by holding public breakfasts, described as a 'fancy-dress dejeuner' and at which she recites her comically execrable poem, Ode to an Expiring Frog. The parallels between the parody and real life are strong and although the young Dickens only visited Suffolk as a *Morning Chronicle* reporter covering election meetings in East Anglia in 1835, nine years after Cobbold's death, it seems very likely that he was aware of her reputation.

Another memorial, this time in the churchyard, to John Coleridge Patteson – who was related to the poet, Samuel Taylor Coleridge and bishop of Melanesia – appears to be at St Mary-le-Tower by dint of his distant relationship to the Cobbold family. Renowned for his linguistic prowess, he was supposed to have learned twenty-three of the thousands of languages spoken in the Melanesian islands. His communication skills appear to have failed him, however, because he was killed by the natives of Nukapu in the Solomon Islands. His connections with Ipswich were negligible although after his death in 1872, the local newspaper reported that he had left over £12,000 in his will (to missionary work) and had been 'murdered by savages.'

Probably because of the civic importance of the church and the nearby Archdeacon's House, Tower Street became a prestigious address in the centre of town. Among its

Above: Memorial to Elizabeth Cobbold in St Mary-le-Tower.

Right: The Admiral's House.

residents was Admiral Benjamin Page, who had been brought up in Northgate Street and retired to Ipswich after a long naval career, and lived at No. 13 Tower Street, now known as The Admiral's House. He painted pictures of various naval scenes in retirement, some of which are in the town hall.

A thriving pub in Tower Street in recent times, The Rep was originally built as a lecture theatre in 1879 for the nearby Mechanics' Institute. Having then been converted into a cinema, Poole's Picture Palace, in 1909, it eventually became home to the Arts Theatre. From 1947 until it moved to the purpose-built New Wolsey Theatre in Civic Drive, the Arts Theatre was home to a repertory company that was recognised nationally as being among the leading theatres and helped launch the careers of many actors including Ian McKellen, Ben Kingsley, Pam Ferris, and Ipswich-born Trevor Nunn, who started out as an Assistant Stage Manager there.

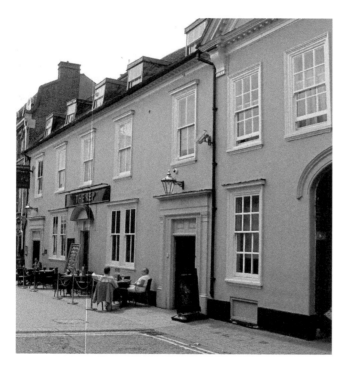

The Rep, now a pub, but once the home of the Arts Theatre.

DID YOU KNOW THAT...

The building that is now The Rep was originally a lecture theatre for Ipswich Mechanics' Institute and Charles Dickens returned to Ipswich in 1851 to give a lecture on its opening night. Dickens' first visit to the town in 1835 had left him singularly unimpressed. On that occasion, he had described Ipswich as 'the dullest and most stupid place on earth.'

13. Clocks and Bells

Dial Lane was known as Cook's Row from around the middle of the fifteenth century. Chaucer's Malyn ancestors owned a tavern here too, probably on the corner of Tavern Street, opposite their other premises. It was in the area known as the Cloth Market, but when that moved up to the Cornhill in 1447, this narrow lane became known for its hot food shops, selling cooked items, such as pasties and pies. These shops were the mediaeval equivalent of fast food outlets. It was unusual for anyone but the relatively wealthy to have kitchens in their houses, so most people who lived in towns relied on buying hot food from places like Cook's Row. An unwanted side effect of this trade was that it was common for fires to break out there. Although most of the buildings in Dial Lane look very old, many of them have been substantially rebuilt and restored over the centuries following disasters of this kind.

The name Dial Lane, which was used simultaneously with Cook's Row for a while, came into use because of a giant clock that stuck out from the tower of St Lawrence's

Dial Lane.

church across what was always a very narrow alleyway. If contemporary drawings are to be believed, it must have been quite hazardous. It was removed when the church tower was restored in 1882.

Some of the reconstructed buildings in Dial Lane borrowed the design for their attractive bow-fronted windows from those in the Ancient House nearby in the Buttermarket. Those in Dial Lane date from the nineteenth century the style of which was copied throughout the country and became known as the 'Ipswich window.'

One of the most interesting buildings in Dial Lane is now Pickwick's Coffee and Tea Merchants. The building itself dates back to the sixteenth century. It is a very attractive building in its own right, but the addition of some remarkable Art Nouveau decoration from the time when it was an optician's shop in the late nineteenth century has made it particularly interesting. They are very much in the style of the Scottish architect, Charles Rennie Mackintosh, and are thought to have been the work of Ipswich architect, J. S. Corder, yet another member of the Ransome family.

The ornate wrought-iron gates are particularly good examples of the Art Nouveau style and the design includes the shape of a pair of spectacles. These may well be the same enormous pair of glasses that once stuck out from the side of the shop front in the early twentieth century. They can be seen on old photographs of Dial Lane. It appears that Mr Scarborow was quite adept at publicising his optician's business. In 2013, a large

Above left: A fine example of the 'Ipswich window.'

Above right: The gate to Pickwicks' coffee shop clearly showing signs of its former use as an optician's.

advertisement painted on the brickwork of this building boasted of his association with the East Suffolk and Ipswich Hospital in Anglesea Road.

The magnificent tower of St Lawrence's church dominates Dial Lane. It has the oldest circle of five bells in the world, dating from the middle of the fifteenth century. They were sent to be restored at the famous Whitechapel Bell Foundry in London in 2009, but were originally cast in the fifteenth century, four of them in 1450 and the fifth in about 1480.

Centuries of use and in more recent times exposure to the polluted atmosphere of a modern urban centre, has meant that St Lawrence's church became very dilapidated, so much so that it was too expensive to restore. After a great deal of discussion between various interest groups, the Borough Council funded its use as a community centre, probably the most sensitive solution to what had become an intractable problem.

Above left: This advertisement for Scarborow's opticians was only revealed during restoration work a few years ago.

Above right: Shears at St Lawrence's church, a reminder that the area was once the town's Cloth Market.

DID YOU KNOW THAT...

There is still a reminder that Dial Lane was once the place where the town's Cloth Market was held. On the east side of St Lawrence's church there is a small panel, probably a Victorian reproduction, that contains a stone moulding in the shape of a large pair of tailor's shears.

14. Evangelists and Abolitionists

Tacket Street, known as Tankard Street for most of the eighteenth century because of the prominence of the Tankard Inn and its theatre, is home to one of Ipswich's least well-kept secrets. It is now well known that one of the most famous English stage actors of all time, David Garrick made his stage debut here in 1741, playing an African slave in Thomas Southerne's drama, *Oroonoko*. Ipswich historian, G. R. Clarke and others believed he actually debuted two years before this under the stage name of Lyddal, in the role of Dick in *The Lying Valet* but this has been disputed.

The Tankard was first opened in 1762 and closed in 1961. It was replaced by a Salvation Army Citadel, which has in turn been demolished. The grand house which the tavern replaced was the Ipswich residence of the very wealthy Wingfield family and Queen Mary I stayed there in 1553.

Tacket Street has an association with a much less well-known figure, that of Susanna Harrison. Although virtually unheard of now, she published poetry that made her

Nothing is left of either the Tankard Inn or its theatre.

internationally famous for a short time at the beginning of the nineteenth century. A collection of her verse, *Songs in the Night by a Young Woman under Heavy Affliction*, published in 1780, was a best seller in the United States where 133 of her poems have since been set as hymns. The book was repeatedly published – there were at least twenty-one editions in Britain and the United States. Nevertheless, she is largely – some would say deservedly – forgotten now, although G. R. Clarke thought her important enough to mention in his *History of Ipswich*:

> This woman, uneducated, and in an humble sphere of life, was confined to her bed for many years. She bore her affliction with pious resignation; and amused herself with the composition of poetry, consisting principally of religious effusions.

Harrison, who had supported her family by working as a servant following her father's early death until her own health gave way, was a member of the Congregational Church in Tacket Street. When she was twenty years old, she gave the manuscript of *Songs in the Night* to Revd John Conder, who was the minister there. He edited her work and prepared it for publication. It is unlikely that Susanna lived to see the success of her poetry. Four years after her death, the poems were published in an edition that included a memoir of her last days called *A Remarkable Scene in the Author's Life*, which was anonymous, but may have been by Conder although he died soon after Harrison in 1781.

The Congregational churchyard.

There were multiple editions of *Songs in the Night* and it became an important evangelical work. Its deeply religious, self-effacing tone is very unfashionable now and it is difficult to appreciate quite how popular her poetry was in the period following her death. Harrison was buried in the churchyard in Tacket Street. Her gravestone has disappeared, but the inscription read:

'SUSANNA HARRISON died 3d August 1784, aged 32.
 'During twelve years affliction, she discovered a gracious spirit; and was the Author of The Songs in the Night.
 'She being dead, yet speaketh.'

The Conder family, who were closely associated with the Congregational Church in Tacket Street, as well as with the east end of London, were interesting in their own right. The Reverend John Conder was for many years a teacher of theology at colleges in Mile End and Homerton. Born in Cambridge, his connection with Ipswich came through his marriage to Susan Flindell, the daughter of a leather seller in the town, in 1744. Of their seven sons, two became prominent in very different walks of life. James Conder, although his main occupation was running a draper's shop, first in Tavern Street and then in the Buttermarket, was a coin expert and antiquary who specialised in trade tokens, which were used instead of standard currency in some areas. Following his sudden death in 1823, his shop on the corner of the Buttermarket and St Lawrence Lane was taken over by his son, James Notcutt Conder. When this old timber-framed building was demolished in 1863 more than one hundred silver pennies dating from the reign of Æthelred (c. 968–1016 – commonly known as Ethelred the Unready), were found under a staircase. Some of the coins were made in Ipswich which had an important mint close to Carr Street in the town centre that produced coins between around 973 and 1210. Although the find in Conder's shop seems likely to have been a hoard, stashed away from a much earlier time, it is possible that the coins had been collected by Conder himself and hidden there by him.

The Revd John Conder's grandson was the writer and abolitionist, Josiah Conder, who never lived in Ipswich but undoubtedly had a connection with the town through his relations at the Tacket Street church. He would have also known other members of the anti-slavery movement, which was very strong locally. Thomas Clarkson of Playford Hall and the Alexander family of Ipswich were prominent abolitionist figures on the national stage. All three appeared in a famous painting by Benjamin Haydon, called *The Anti-slavery Convention 1840* which is now in the National Portrait Gallery and features in an interesting footnote to Ipswich history.

Painted in 1841, but clearly based on the actual event of the preceding year, it shows all the great and good of the anti-slavery movement on both sides of the Atlantic gathered together for the Convention. Also present were several women abolitionists and James Beckford, an emancipated slave, who was one of a tiny number of black figures. The painting was owned by the British & Foreign Anti-slavery Society (BFASS) but had not been a success when it was exhibited and it was put into storage until 1847 when the Ipswich Museum borrowed it to celebrate the opening of its new premises (see chapter four). No doubt the involvement of the Alexander family in the museum was an

Above left: Ipswich had a strong involvement in the campaign to abolish slavery and now has many streets named after some of its leaders. Wilberforce...

Above right:...and Thomas Clarkson.

important factor. George William Alexander, who featured in the painting, was treasurer of the BFASS. Another relative, by marriage, and a fellow Quaker, George Ransome, was the honorary secretary of the museum at the time.

The painting had been on show at Ipswich Museum for thirty years when the London-based Anti-slavery Society suddenly took a new interest in the painting and demanded that it was sent back to the National Portrait Gallery. The trustees of Ipswich Museum had other ideas however. They claimed the painting now belonged to Ipswich because it had been in the Museum's possession for so long and had been cared for and restored at its expense. After a great deal of legal wrangling, the museum's committee gave way and *The Anti-slavery Convention 1840* was eventually sent to the National Portrait Gallery, where it remains to this day.

DID YOU KNOW THAT...

Tacket Street, now one of the most unattractive parts of town, was once known as the grandest street in Ipswich. J. E. Taylor described it in his *In and About Ancient Ipswich* (1888): 'The merchant princes of Ipswich lived near their warehouses and shipping; they built houses where they conducted their businesses; perhaps blended work with pleasure – smoked pipes, drank wine or Hollands, Nantz or Cognac with their customers.'

15. Varieties of Palaces

The ancient buildings on the corner of the mysteriously named Silent Street and St Nicholas' Street are obviously very old but what is less well-known is that the modern glass and metal building on the other side of Silent Street, which houses shops and a wine bar today, was the site of another great palace from the Tudor period. This was known as Curson's Palace, built in 1460, and the half-timbered buildings that remain on what would have been an extensive site formed Curson's Lodge, where visitors to the palace were accommodated.

In the sixteenth century, Lord Curson's home was the largest private dwelling in Ipswich and it was described by the local historian John Glyde, as 'having many large and beautiful rooms, a porch under which a carriage could pass and extensive stabling and coach houses.' There was also a chapel in the grounds as was the custom at that time.

Sir Robert Curson (sometimes spelt Curzon), later Lord Curson, was from a Suffolk family who held substantial property in Blaxhall and Saxmundham among other places. He lived the usual precarious life of someone involved in Tudor politics and was twice indicted for treason, but managed to escape punishment and die in his bed. Whether this was because he was adroit at changing sides at the right moment, or was too valuable to his masters, particularly Henry VIII, who visited him in Ipswich, or was – as some people alleged – working as a spy, is unknown. Cardinal Wolsey coveted the palace, which was close to his planned college and wanted to evict Curson, who was only was saved from losing his house, or worse, by Wolsey's own demise.

After Curson's death the palace became known as the Bishop's Palace, and was used as the Ipswich residence of the bishop of Norwich who had jurisdiction over Suffolk. Sixteenth- and seventeenth-century documents show that the building was leased from the king.

By the beginning of the nineteenth century, Curson's Lodge was in use as a pharmacy. Since then the buildings have been a beer shop, sold clothes and, from 1944 to the present, were the premises of Cox's antiquarian bookshop. The building at the front, facing on to St Nicholas Street was empty for many years, and quite neglected, before it was restored by the Ipswich Building Preservation Trust in 2007.

In 2013, a car drove into the recently restored Curson's Lodge, knocking down one of its carved wooden posts. During the repair work, the *East Anglian Daily Times* reported that workmen found a small blue chemist's bottle containing a shop fitter's receipt and a business card with the signatures of the carpenters and bricklayers who did the work on the building in 1902, an appropriate 'time capsule' for one of the oldest buildings in Ipswich.

Opposite the site of Curson's Palace is a much later, but equally imposing building, now a hairdresser's, which used to be known as The Sailor's Rest. A plaque on the building,

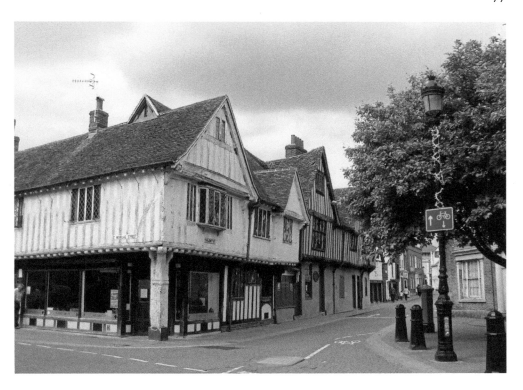

Above: Curson Lodge.

Right: Carved post at Curson's Lodge.

The site of Curson's Palace.

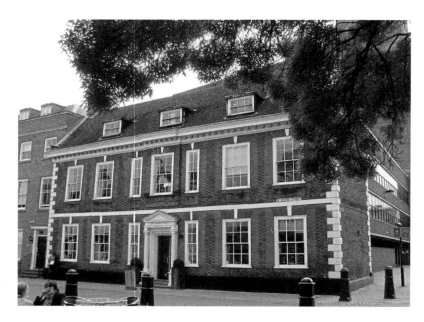

The Sailor's Rest.

put there in 1982 by the Ipswich Society describes it as a 'unique William & Mary house used by the British & Foreign Sailors' Society 1925–57.' The building had been a private residence up until 1925 and was remarkably grand for the purpose it had now been given, to provide a café and reading room for sailors who were in the town. It was threatened with demolition in 1970 but saved after members of the Ipswich Society demonstrated that the building was in sound condition.

Near to here, on the corner of Wolsey Street and Franciscan Way, the remains of what might be Ipswich's earliest immigrants were discovered in the graveyard of the old friary there. During three separate excavations, local archaeologists found many skeletons, nine of which came from sub-Saharan Africa. Subsequent investigations, including carbon dating, have led scientists to conclude that these people came to Ipswich from North Africa in the thirteenth century, perhaps returning with soldiers from the Crusades. They may have been at the friary when they died because they were receiving medical treatment, something for which the Franciscans were well known, as several of the skeletons were identified as having serious diseases.

The Hippodrome was one of St Nicholas' Street's most famous buildings and it was the creation of its owner Edward Bostock who had already successfully opened the Norwich Hippodrome in the old Theatre Royal there. It opened on 27 March 1905 and Bostock donated the proceeds of the opening to the Ipswich and East Suffolk Hospital in Anglesea Road. Part of the opening ceremony involved a parade through the town centre led by Madame Florence, who walked all the way from Whitton to the Cattle Market on a large globe, and a troupe of circus elephants performing various tricks. These publicity stunts were a great success in the town and, as a result of such a successful opening, the Hippodrome enjoyed many successful years and became Ipswich's own extremely popular 'Palace of Varieties.' Bostock booked all the top performers over the years, from the music hall singer Marie Lloyd via George Formby to Roy Castle who appeared there just before the Hippodrome closed its doors as a variety theatre, on 10 August 1957. In between the town saw the likes of Max Miller, Tommy Cooper (both in 1949), and Peter Sellers in 1956, as well as musicals like *The Desert Song* and serious drama such as R. C. Sherriff's *Journey's End*. In 1957, the Hippodrome became a bingo hall and, two years later, having been bought by the then chairman of Norwich City Football Club, Geoffrey Watling, it was turned into a ballroom. It was at that time that the beautiful theatre interior designed by Frank Matcham in the early 1900s, was destroyed. After this, the Hippodrome became a concert venue until it was closed and finally demolished in April 1984.

DID YOU KNOW THAT...

During the Second World War, the Hippodrome's entertainments included performances – if they can be called that – by naked women. Under rules laid down by the Lord Chamberlain, who controlled theatrical censorship at the time, nudity was allowed as long as the women (it was only women at that time) did not move, so they held still poses on stage. One of the most popular acts featured actresses posing as 'Jane' a character from a cartoon in the *Daily Mirror*, famous for inevitably losing her clothes. It was all supposed to help (male) public morale at the time. At Ipswich Hippodrome, Ron Chapman had been employed to do the lighting for these performances, as he recalled in David and Morson's history of the theatre. He was twelve years old at the time.

16. 'So Entirely Demolished, That Not the Least Rubbish of It Is to Be Found'

The area around Elm Street and Black Horse Lane is old and was known, even as late as the twentieth century as The Mount. This refers to ancient history when it was the site of Ipswich's motte-and-bailey castle, which is thought to have been on the site between St Mary Elms in the south and Westgate Street in the north. Its exact location has been hard to establish because it was destroyed completely sometime between 1173 and 1176, after it was besieged by Henry II's army. In the *Suffolk Traveller* (1735), John Kirby wrote that the castle was 'so entirely demolished, that not the least Rubbish of it is to be found' and this appears to have been true as nothing has ever been found to establish its exact site. The upper structure would have been made of wood so it would have been quite easy to dispose of, but the earthworks, such as the motte or mound upon which the other fortifications were built must have been quite deliberately razed to the ground.

Ipswich Castle was reputedly taken down by the king's engineers and its complete destruction was presumably intended to be a lesson to both the people of Ipswich and the powerful Bigod family who, although they were based at Bungay Castle in north Suffolk, occupied Ipswich Castle as part of their massive power base in East Anglia. Hugh Bigod – who famously was supposed to have bragged 'If I were in my castle upon the Waveney/ I would ne care for the king of Cockney' – had supported Henry II's sons in a rebellion and must have been perceived as a serious threat to the power of the Plantagenet monarchy. It is quite believable that the king not only wanted to make an example of the town by completely destroying its castle but that, less than thirty years later, one of his rebellious sons, who had by then become King John, rewarded the town with a royal charter granting it self-government.

The church of St Mary Elms was built after the castle had been destroyed and, although it is very old, has been rebuilt and restored several times. Its brick tower, which has the town's oldest working clock, dates from around 1443 but even as recently as 2010, it had to be substantially restored following an arson attack which caused considerable damage. St Mary Elms is also home to the new shrine of Our Lady of Grace, where a replica of the statue of the Virgin Mary from Nettuno in Italy (see chapter one) is kept.

Opposite St Mary Elms are Mrs Smith's Almshouses, which are less well known than others in the town such as Tooley's Court. These neat dwellings were named after Mrs Ann Smith of London who presumably had some connection with Ipswich that hasn't been recorded. She left £5,000 to build the houses, which were constructed in 1760. The almshouses were administered by trustees appointed by the churches of St Mary Elms and St Peter's, and, as the plaque on the building states, they were 'for the Benefit of twelve poor Women of honest Life and Conversation of the Age of fifty Years and upward being Communicants of the Church of England.'

The Black Horse Inn, which gave its name to the road it stands in (until the nineteenth century it was called Burstall Lane), was built in the fifteenth century but was a private

Rightt: The door to St Mary Elms.

Below left: St Mary Elms.

Below right: A new shrine to Our Lady of Grace in St Mary Elms.

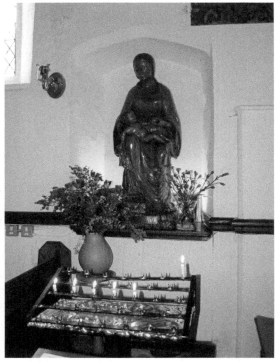

The plaque on Mrs Ann Smith's almshouses.

Close to St Mary Elms, this is thought to be one of the oldest houses in Ipswich.

house until sometime after 1689. At this date, records show there were only two licensed premises in the parish, the White Lion (now the Golden Lion) and the Crown (location unknown). The beautiful old house next to the Black Horse, which can be glimpsed through the churchyard of St Mary Elms, is of a similar age. This area, despite its elegant houses, had become quite deprived in the eighteenth and nineteenth centuries. It's possible to see from the census returns of 1871 and 1881, for example, that people who lived at 'the Mount' were labourers, laundresses, charwomen and shoemakers. The Black Horse itself appears to have had something of a bad reputation and was the place where recruiting sergeants for the militia and the regular army would come regularly to find prospective soldiers among the drinkers and ne'er-do-wells there. Both the husband of

the poet Ann Candler (see chapter twelve) and Charles Catchpole, the brother of the more famous Margaret, were recruited here.

The Black Horse appears to have improved its status towards the end of the nineteenth century as, according to Leonard P. Thompson's *Old Inns of Ipswich*, it was a 'fashionable mid-morning rendezvous for doctors, lawyers, and tradesmen.' Writing in 1946, he added,

> today the Black Horse still fulfils all the essential offices of the English Inn; members of the theatrical profession especially have good cause to remember the quality of its hospitality, and mine host and hostess are justly proud of the spontaneous inscriptions in the 'Remarks' column of the Inn's Visitors' Book.

We can only imagine what those remarks were.

The Black Horse.

DID YOU KNOW THAT...

Despite being a High Anglican church in recent times, St Mary Elms was the place where Ipswich's Huguenots worshipped. They were Protestant refugees who had fled from religious persecution on the European mainland in the sixteenth century. One of them, Balthazar Gardemau, born in Poitiers, France in about 1656, was stipendiary curate here and later became Vicar of Ashbocking in Suffolk. The French weavers had been invited to Ipswich by its governing authority because of their skills in making silk and linen goods, but the scheme was unsuccessful and many of them moved to other towns and cities. According to legend, Gardemau had a large stone coffin prepared for his death and used to lie in it, practising for death. When he did die in 1720, he left £200 for 'poor French Protestants.'

17. Courtyards and Gardens

From the 1960s until 1998, an old half-timbered house at the bottom of St Stephen's Lane was a bookshop with the intriguing name of Atfield and Daughter. It is now a fancy dress costume shop owned by the same family but they have opened the building and courtyard, known as xxxxx to the public on occasions. It has a fascinating history: several archaeological finds have been made on the site including pottery dating back to AD 650 and a human skeleton.

Another old Ipswich courtyard, Hatton Court, is equally difficult to find as it is tucked away behind the churchyard of St Mary-le-Tower. In Clarke's *History of Ipswich*, he refers to 'a court leading from Tavern-street into the churchyard of St Mary at the Tower, called Hatton-court, [where] formally resided Sir Christopher Hatton; who danced himself into the good graces the Queen Elizabeth, and in the process of time, became lord high chancellor of England.'

Although it has been claimed that Hatton was born here, and therefore that this small town has produced two lord chancellors of England in a relatively short time – the other, of course, being Cardinal Wolsey – it's hard to find any formal connections between Christopher Hatton and Ipswich other than that he must have lived here at some time. His family was from Northamptonshire, a county that he represented in parliament and it seems likely that he was born there. His connections with Ipswich are obscure, but then looking at his portraits, it's also difficult to believe Clarke's other story about him: how this rather portly and stuffy looking figure could ever have been so famous for his elegance and his dancing prowess as to have become a favourite of Elizabeth I.

Early maps of Ipswich show that courtyards of this kind were commonplace at one time, particularly outside the larger private houses as well as hotels and inns. A much more unusual feature for a town of this size, however, which can also be seen quite clearly on Joseph Pennington's map of Ipswich, first published in 1778, was the remarkable number of large and well laid-out pleasure gardens and orchards. In *The Suffolk Traveller*, John Kirby noted that 'most of the better Houses, even in the Heart of the Town, have convenient Gardens adjoining to them, which make them more airy and healthy, as well as more pleasant and delightful.'

Most of the area between Falcon Road and the Buttermarket, for example, much of which was the property of by slave-owner Jonathan Worrell Esq., appears to have been planted as formal gardens, and the area between Westgate Street and St Mary Elms was almost completely cultivated, if Pennington's map was accurate. An advertisement published when Jonathan Worrell put his property up for sale in 1781 confirms that it boasted a 'large garden walled round, and planted with the choicest Fruit Trees, Buildings totally detached, and the Entrance by a handsome Court Yard with Iron Palisades.'

Pennington's map also shows houses owned by Mrs Hamby and J. Cossey Esq., which had gardens of a considerable size right in the heart of the town. In her home at Turret

Above left: Hatton Court.

Above right: A glimpse of the Unitarian Meeting House courtyard.

House in Turret Lane, Mrs Sparrow – presumably a member of the same family that owned the Ancient House in the Buttermarket – was surrounded by gardens and orchards. Turret House was demolished by 1844 and there are modern apartment blocks on the site now. It is a completely developed, urban part of town that includes the Old Cattle Market bus station, but in the eighteenth century, Turret House was surrounded by orchards: Mr Griggs' Orchard, Mr Garnet's Orchard, Nagshead Orchard and Mr Sorrel's Orchard were on three of its four sides. It must have been extremely pleasant in spring and summer. By the beginning of the nineteenth century, however, most of Ipswich's famous gardens had gone, lost underneath the more familiar shops and factory buildings we see today.

Not everyone was impressed with the town's courtyards and gardens, however. François de la Rochefoucauld, who wrote about his year-long visit to Suffolk in 1784, didn't like Ipswich very much, complaining that 'the town is badly built, the streets narrow, without any alignment, and the road-surface as bad as could be.' He did, however, rather grudgingly mention that Ipswich was increased in size by its large number of gardens and that 'this makes the air very salubrious.'

An earlier visitor, who did admire the town for its greenery and 'salubrious air' was Daniel Defoe. In his *Tour Through the Eastern Counties of England* (1722), Defoe praised Ipswich and mentioned what was probably its most famous garden, a 'physic garden' belonging to a local doctor and advocate of smallpox vaccination, Dr Beeston (1671–1731):

There are some things very curious to be seen here, however some superficial writers have been ignorant of them. Dr. Wiliam Beeston, an eminent physician, began a few years ago a physic garden adjoining to his house in this town; and as he is particularly curious, and, as I was told, exquisitely skilled in botanic knowledge, so he has been not only very diligent, but successful too, in making a collection of rare and exotic plants, such as are scarce to be equalled in England.

Although the garden was the work of Beeston, it became better known as Coyte's Gardens after his great-nephew, William Beeston Coyte (*c.* 1741–1810), who continued his work after the property was bequeathed to him. He practised medicine at Ipswich, published an essay on a possible cure for epilepsy, and had an interest in botany and the cultivation of the garden that led him to extend the range of plants to include fewer exotic species and more native British plants. Coyte was a member of the Linnaean Society from 1794 until his death in 1810, and he compiled two catalogues of his plants. The first, *Hortus botanicus Gippovicensis*, or a *Systematical Enumeration of the Plants Cultivated in Dr Coyte's Botanic Garden at Ipswich* was published in 1796.

The eighteenth century also saw the popularity of another type of urban garden, the pleasure garden. They were famous – indeed, notorious – in London where the behaviour of people of all classes and backgrounds who socialised as they would not normally do,

Coyte's Gardens.

often wearing masks, had created a great deal of scandal. Provincial towns began to imitate them on a smaller, and probably a much less riotous, scale. In Ipswich, the Royal William, a public house in London Road, opened the Royal William Gardens, also known as the Vauxhall Gardens, after one of the better-known London enterprises.

An advertisement in the *Ipswich Journal* of 10 November 1860 described the Royal William:

A first rate Tavern and Pleasure Gardens: An old established free house, eligibly situated in the populous and rapidly increasing County Town of Ipswich. ... The Royal William Situate near the entrance to the town of Ipswich on the London Road. ... The Pleasure Grounds, well known as the 'Vauxhall Gardens' consists of a spacious promenade green, on either side of which are placed an orchestra with retiring room; saloon, adapted for accommodation of nearly 2,000 persons, fitted with bar and music gallery; refreshment booths and boxes, an excellent and secluded bowling green, lawn and parterres, tastefully laid out and planted with shrubs and flowers in rich profusion and covering altogether an AREA OF FOUR ACRES (or thereabouts) intersected by winding paths and extending on a gentle slope from the house towards the picturesque banks of the 'Gipping' whose 'limped flood' washes the southern extremity of the grounds.

In 1873, the famous acrobat Blondin, who had crossed the Niagara Falls on a tightrope put on a performance at the Royal William's Pleasure Grounds. The *Ipswich Journal* reported: 'the performance included the daring feat of passing along a rope fifty feet above the ground on a bicycle, The grotesque one of cooking an omelette on the rope, and the incomprehensible one of passing along the rope enveloped in a sack.'

Blondin was a huge success and although entertainments as vast and impressive didn't continue at the site, local bands were still playing there during the 1970s. After briefly being re-named Hoofers, the Royal William reverted to its old name but it was demolished in 1989, and there is now a Lidl supermarket on the site of Ipswich's old pleasure gardens.

DID YOU KNOW THAT...

Behind Atfield's shop in St Stephen's lane is one of Ipswich's oldest courtyards, of which there would have been many in the days before the town was developed and many mediaeval buildings were knocked down. Sun Court was not built as an inn, although it was one for about two hundred years, according to Leonard P. Thompson, author of *Old Inns of Suffolk*. Until the eighteenth century – it was built in the sixteenth – it was a private residence. It's possible that when it became an inn, it served the drovers and cattle-dealers that came to the Old Cattle Market close by. However, according to Thompson, the Sun 'enjoyed... a considerable and unenviable reputation, which may or may not have been a contributing factor to its surrendering its licence.' The Sun Inn, by then one of many public houses in Ipswich owned by the Cobbold brewery, closed its doors at the end of January 1901, but its painted sign can still be glimpsed in the courtyard.

Left: Sun Court.

Below: The moulded sun sign.

18. A Secret Language

Surely the most distinctive aspect of Ipswich's historic past, and something that brings that history to life in a way that books and old manuscripts cannot, are the many examples of carvings, particularly in wooden gate posts and angle posts holding up the half-timbered building that have not been destroyed by the town's modernisers, and the pargetting that is very much a feature of Suffolk and Essex architecture but relatively unusual elsewhere.

Pargetting is a form of ornate, decorative plasterwork, sometimes painted, but often left plain. Examples can be seen on buildings all over Suffolk, but Ipswich can boast of some of the highest quality work of all, particularly on the famous Ancient House in the Buttermarket. The gilded and painted Royal Coat of Arms is perhaps the most noticeable thing about this building, but the five bays at the front have beautifully executed pargetting depicting Atlas holding up the globe and four continents: Europe, America, Africa and Asia. Of course, Europeans were not aware that the land mass that would become Australia existed when the work was being done in the seventeenth century. Between these plasterwork pictures are other images: festoons depicting the elements of earth (fruit and flowers), air (birds) and water (fish and Neptune) and the building is

Gilded pargetting at No. 14 Northgate Street.

Fine examples of the pargetter's craft on the Ancient House in the Buttermarket.

uniquely decorated with many other examples of figurative plasterwork. Many of them are probably intended to be allegorical but their meaning is difficult for the modern eye to decipher.

The pargetting on the Ancient House was commissioned by its owner in the seventeenth century, Robert Sparrow, and was probably carried out between about 1660 and 1670. The coat of arms, a Royalist tribute to Charles II, supposedly alludes to the story that the fugitive Charles hid in the house after the Battle of Worcester in 1651, but in fact it is more likely to have been added following a formal visit to Ipswich by the king in 1668. However, the Ancient House does have a genuine secret, only discovered in 1801, when a labourer working on some repairs fell through the floor and discovered a secret room. This lent itself to the old tale of Charles II hiding there but it is, perhaps, more likely that the room had been kept secretly there for 150 years, so that the residents could continue to practise the old Catholic faith in times of persecution, or even to hide priests from the authorities.

Many other examples of pargetting have been lost to Ipswich along with the old buildings they decorated. There is still a particularly fine example at No. 14 Northgate Street, however, where the building's number has been beautifully rendered in painted plasterwork. Unfortunately very little is known about who made it or who was living in the building at the time it was created.

Initials in a beam at a merchant's house.

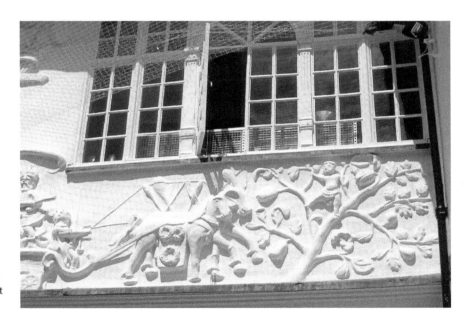

Pargetting in the courtyard of the Ancient House.

The sign that still remains on one of the buildings at Sun Court, at the bottom of St Stephen's Lane, is another example of painted pargetting, although the image of the sun would have been made using a plaster of Paris mould rather than by sculptural techniques.

There are more grotesques in the wood carving to be found around Ipswich. The town still has a number of elaborately carved wooden posts at the entrances to many of its old buildings, although records show that it has lost a great deal of its best. The Old Coffee House on Tavern Street lost some unique examples that were considered

Carving on the old Pack Horse Inn building.

to be indecently vulgar when Tavern Street was widened but it's still possible to see from old engravings what they were like and indeed there were some peculiar figures. These included some strange bare-breasted androgynous figures with cloven hooves, which can be clearly identified in George Frost's illustrations, which were published in G. R. Clarke's *The History of Ipswich* (1830). The carvings were thought to have been destroyed when the front of the coffee house was demolished, but it is possible that some similar wooden figures can be seen today, on Cliff Cottage, the house near the Cliff Brewery where the Cobbold family lived before they moved to Holywells. Fixed onto this building are a number of quite bizarre carvings which have been described as satyresses. This also fits in with the theory that the carvings came from Tavern Street as they were described as 'satyrs' and mythological creatures in their time. Although it's difficult to prove that the carvings came from here – they may have been imported specifically to decorate Cliff Cottage – significantly, both properties were owned at one time by John Cobbold, so it is quite possible that the carvings were not destroyed when Tavern Street was widened after all, but saved at Cliff Cottage.

Most of Ipswich's other carved posts are much less risqué. In Westgate Street, there are still posts carved with grapes and vine leaves, presumably made for a tavern or vintners' shop. One of the two posts is now painted a lurid purple to match the rest of the building and it's easy to walk past them without noticing them at all.

Right: One of many grotesque carvings on Cliff Cottage.

Below: Carvings around a doorway at Cliff Cottage.

A carved wooden beam near the Old Cattle Market.

DID YOU KNOW THAT...

There is a curious example of plasterwork on an old house at No. 11 Eagle Street which is difficult to date. It's a fierce, indeed rather terrifying, face something between a guard dog and a monster, which has led to all kinds of strange tales, including a story about the house having been lived in by an ogre. In fact, the feature may be quite modern. Although the building is older, the front of the house, and the face, probably date from the nineteenth century. It seems odd that the well-known local historian John Glyde who lived next door at number nine, didn't mention this horror, if it had more of a history to it. Perhaps it was nothing more than a visual joke, a Victorian version of the 'beware of the dog' sign.

Ogre or guard dog? The strange face above No. 11 Eagle Street.

Bibliography

Books

Ackroyd, Peter, *Shakespeare: The Biography* (London: Vintage, 2005)

Blatchley, John & MacCulloch, Diarmaid, *Miracles in Lady Lane* (Ipswich: J. M. Blatchly, 2013)

Bounds, Joy, *A Song of their Own: the Fight for Votes for Women in Ipswich* (Stroud: The History Press, 2014)

Cautley, H. Munro, *Suffolk Churches and their Treasures 5th ed.* (Woodbridge: Boydell, 1982)

Clarke, G. R., *The History of Ipswich* (Ipswich, 1830)

Cobbett, William, *Rural Rides* (1830; London: Penguin, 2001)

Copsey, Tony, *Book Distribution & Printing in Suffolk*, 1534–1850 (Ipswich: T. Copsey, 1994)

Davis, Terry & Morson, Trevor *The Hippodrome: the Place to Go* (Stafford: Terence Davis, 2005)

Defoe, Daniel, *Tour of the Eastern Counties* (1722; London: Cassell, 1888)

Glyde, John, *The Moral, Social & Religious History of Ipswich in the Middle of the Nineteenth Century* (Ipswich: J. M. Burton, 1850)

Grace, Frank, *Rags and Bones: a Social History of a Working-class Community in Nineteenth-century Ipswich* (London: Unicorn, 2005)

Kindred, David, *Ipswich: Lost Inns, Taverns & Public Houses* (Ipswich: Old Pond Publishing, 2012)

Kirby, John, 'The Suffolk Traveller' in *Suffolk: His Maps and Roadbooks* (Woodbridge: Boydell, 2004)

Lebow, Eileen F., *Before Amelia: Women Pilots in the Early Days of Aviation* (Washington DC: Brassey, 2002)

Malster, Robert, *A History of Ipswich* (Chichester: Phillimore, 2000)

Pevsner, N., *The Buildings of England: Suffolk* (1961, rev. ed. London: Penguin, 1974)

de la Rochefoucauld, François, *A Frenchman's Year in Suffolk, 1784* (Woodbridge: Boydell, 1989)

Smith, Stanley, *The Madonna of Ipswich* (Ipswich: East Anglian Magazine, 1980)

Tennyson, Julian, *Suffolk Scene* (Wakefield: E. P. Publishing, 1939)

Thompson, Leonard P., *Old Inns of Suffolk* (Ipswich: Harrison, 1936)

Thompson, Leonard P., *Tales of Old Ipswich* (Ipswich: East Anglian Magazine, no date)

Twinch, Carol, *Ipswich Street by Street* (Derby: Breedon, 2006)

Webb, John, *The Town Finances of Elizabethan Ipswich* (Woodbridge: Boydell, 1996)

Articles

Vincent Redstone, 'The Chaucer-Malyn Family in Ipswich', *Suffolk Arch. Inst., XII*, pp. 184–199 (1905)

Revd C. Evelyn White, 'The Old Inns and Taverns of Ipswich', *Suffolk Arch. Inst.*, VI, pp. 136–183 (1886)

Journals

East Anglian Daily Times
East Anglian Magazine
Ipswich Journal
Proceedings of the Suffolk Institute of Archaeology & History
Suffolk Review

Websites

ipswich-lettering.org
racns.co.uk